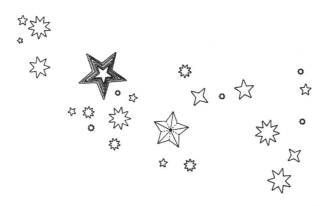

to _____

from _____

the time garden

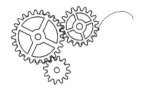

Published in the United States by Watson-Guptill
Publications, an imprint of the Crown Publishing
Group, a division of Penguin Random House LLC,
New York.
www.crownpublishing.com
www.watsonguptill.com

WATSON-GUPTILL and the WG and Horse designs are
registered trademarks of Penguin Random House LLC.

Originally published in Korea by The Business Books
and Co., Ltd., in 2014. Copyright © 2014 by Song Ji-
Hye (Daria Song). English language rights arranged with
The Business Books and Co., Ltd., care of The Danny
Hong Agency, Seoul, through Gudovitz & Company
Literary Agency, New York. English translation by Min
Jung Jo, rights arranged with The Business Books and
Co., Ltd.

Trade Paperback ISBN: 978-1-60774-960-8

Printed in the United States of America

Design by Margaux Keres

20   19   18   17   16   15   14   13   12   11

First American Edition

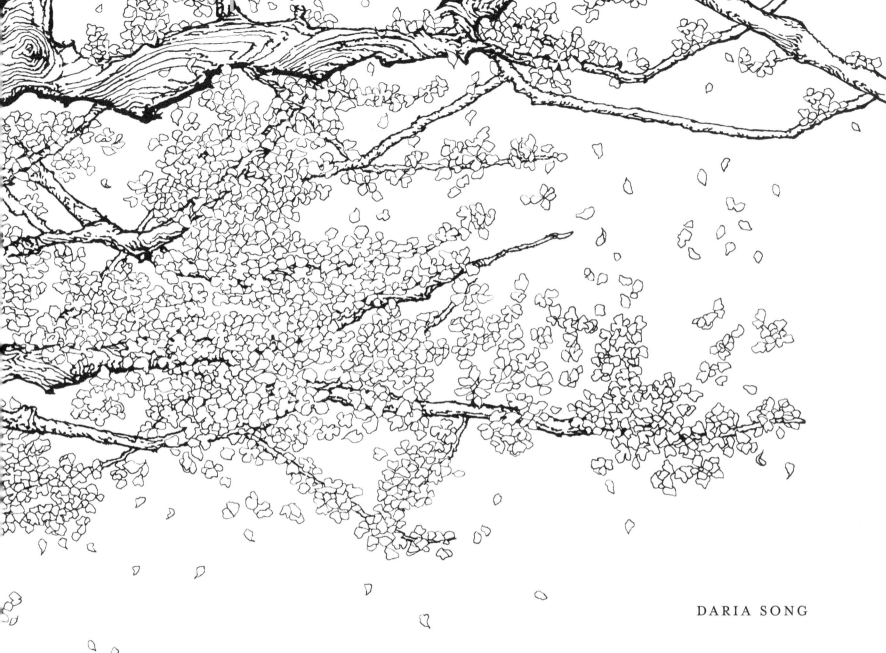

DARIA SONG

# the time garden

A magical journey
and coloring book

WATSON-GUPTILL
Berkeley

## CUCKOO CLOCK USER'S MANUAL

Thank you for purchasing our German
Black Forest Cuckoo Clock.

1. Please handle the cuckoo clock with care.

2. Hang the clock on a strong nail secured
in the wall at a slight upward slant.

3. Do not open any parts of the clock. The company
does not take responsibility for anything that may
happen afterward.

4. Once opened, be careful not to
disturb anything . . . or anyone.

5. Be aware when the clock strikes midnight!

6. Enjoy.

---

This piece is the star of our collection and designed
for the most discerning connoisseur.

1870 Antique Cuckoo Clock, Model #8263
18 x 9 x 6 inches  |  Two-year warranty
Made in Germany

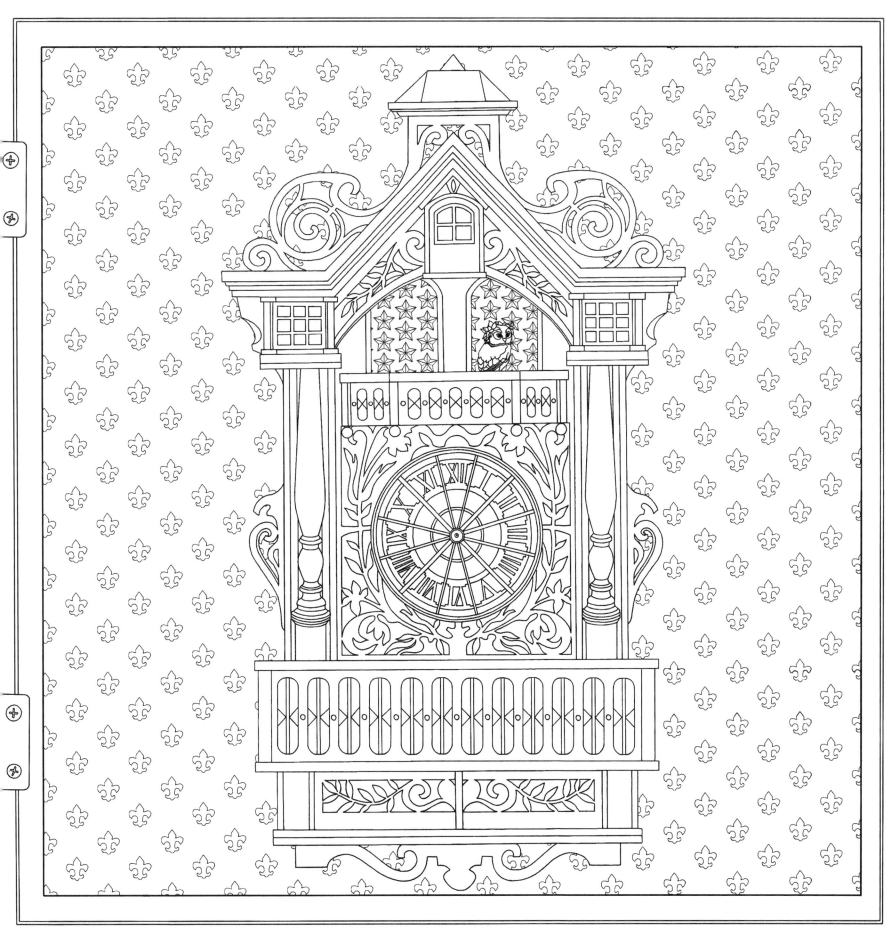

There once was a little girl who had boundless imagination, and exploring was one of her favorite things to do. Every object in the house that caught her eye had a brilliant story of its own.

One day, the little girl's father brought home an antique cuckoo clock from Germany. The girl was captivated by the strange and exotic new clock. She could not understand how it worked without batteries, or any kind of electric power.

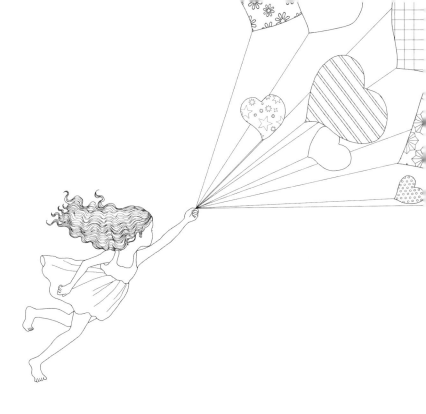

She was so curious that she decided to give it a closer look that night, after her parents went to bed, and she had the whole house to herself.

Cuckoo, cuckoo . . . cuckoo.

When the clock struck its final cuckoo at midnight, she climbed up the wall to take a closer look and was surprised to find a strange, red-haired little fairy inside, winding up the clockwork. The girl cried out in surprise and fell flat on her back.

At that moment, she realized that her house had transformed into something different, something that looked like the exotic new clock from Germany. Just as she recovered her senses, she caught a glimpse of the red-haired fairy dashing away. The girl started to run after the fairy, and soon found herself in a world of fantasy and dreams.

As she continued her journey, she saw a series of beautiful worlds one after the other, each full of mystery and allure. The girl and her fairy friend continued their adventure until she finally encountered the doorway back to reality.

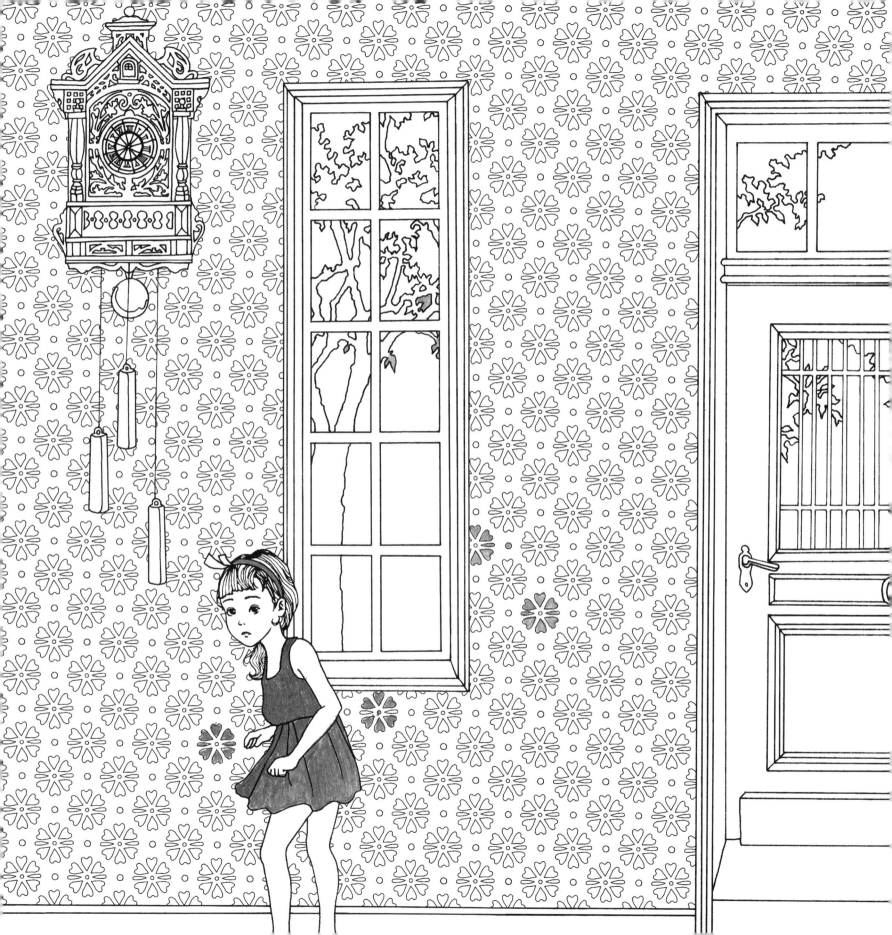

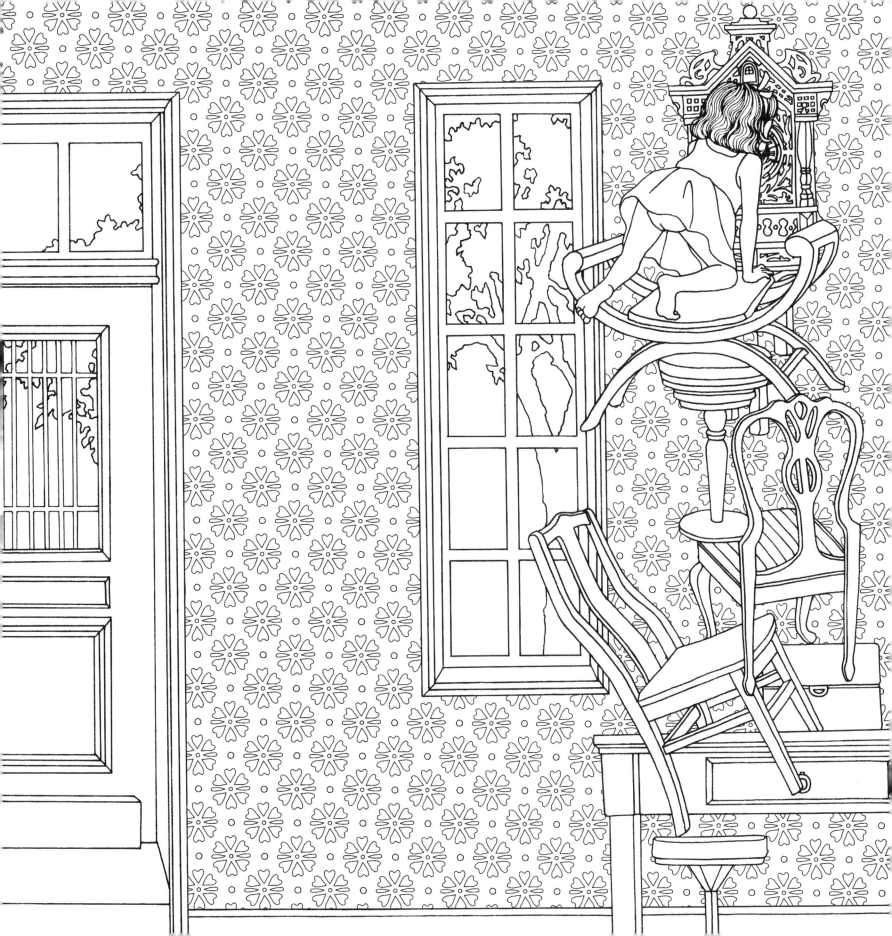

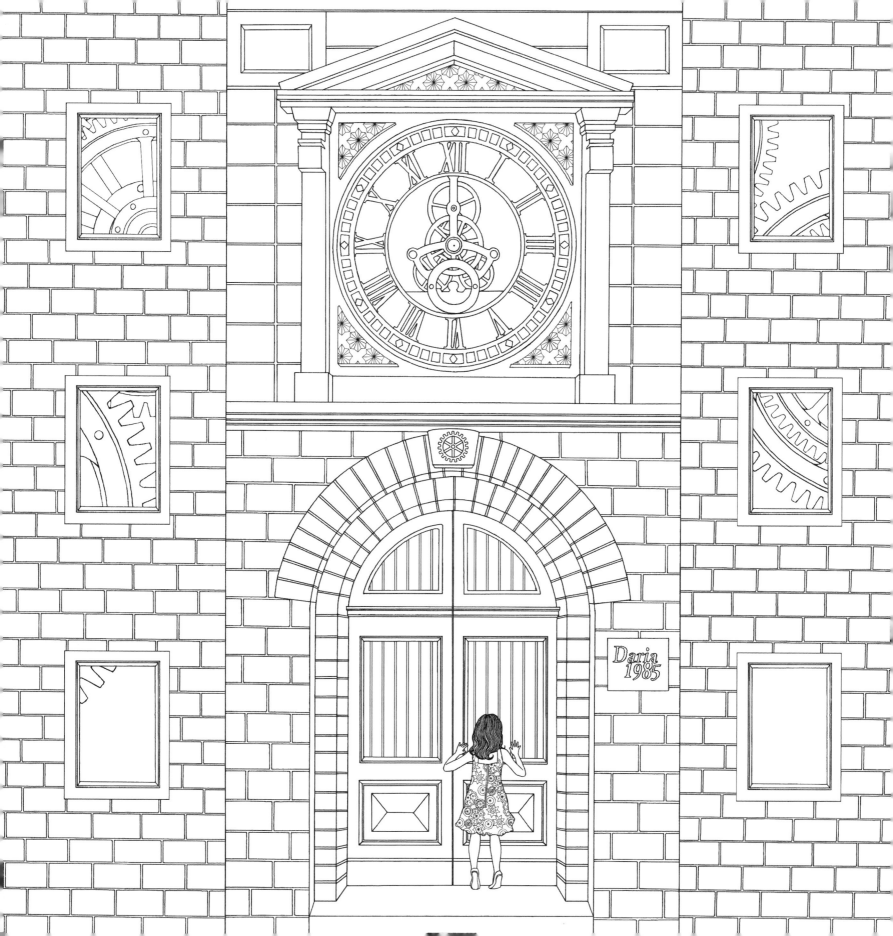

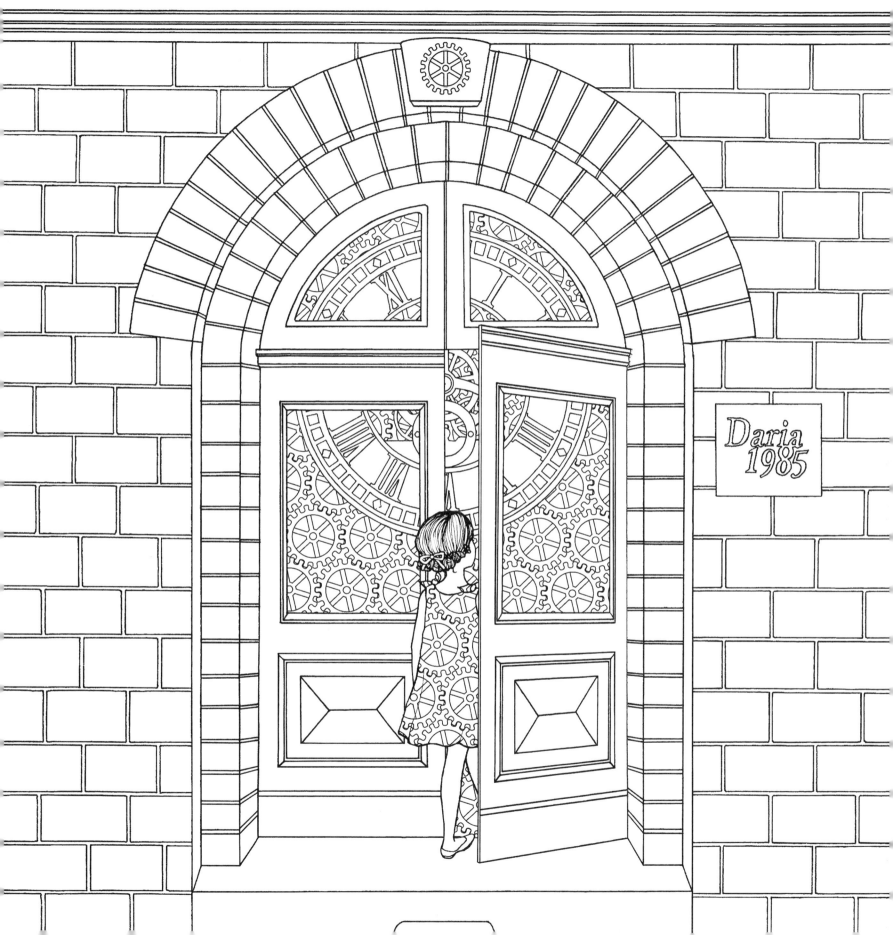

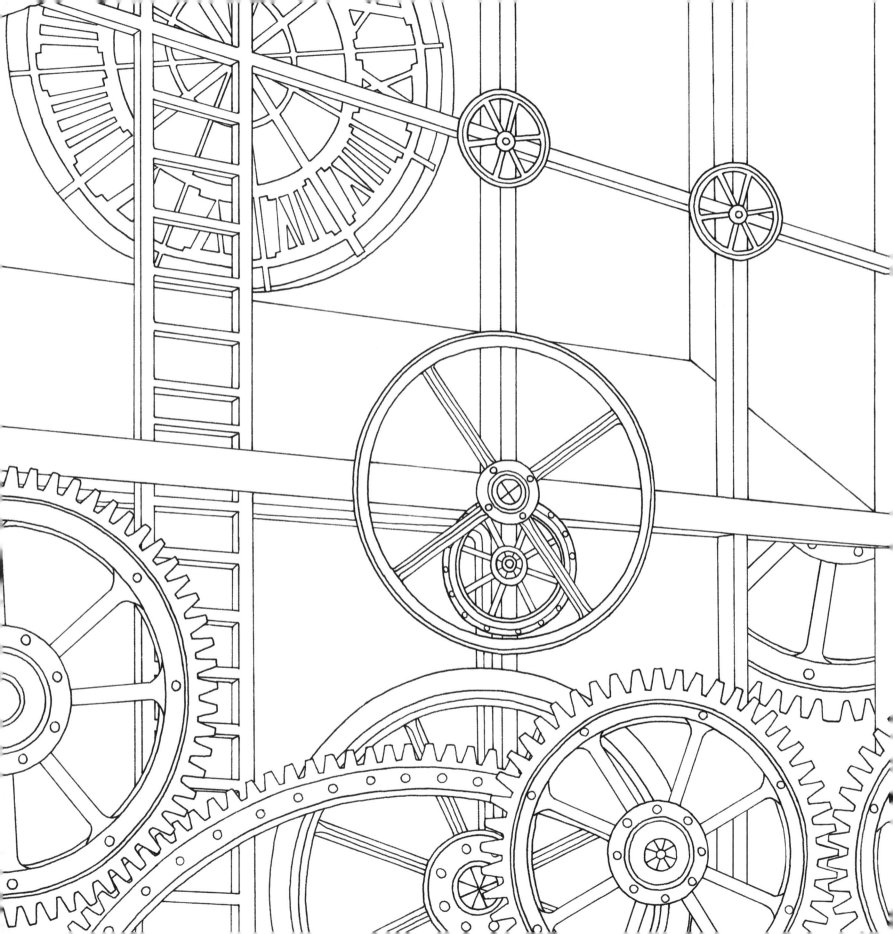

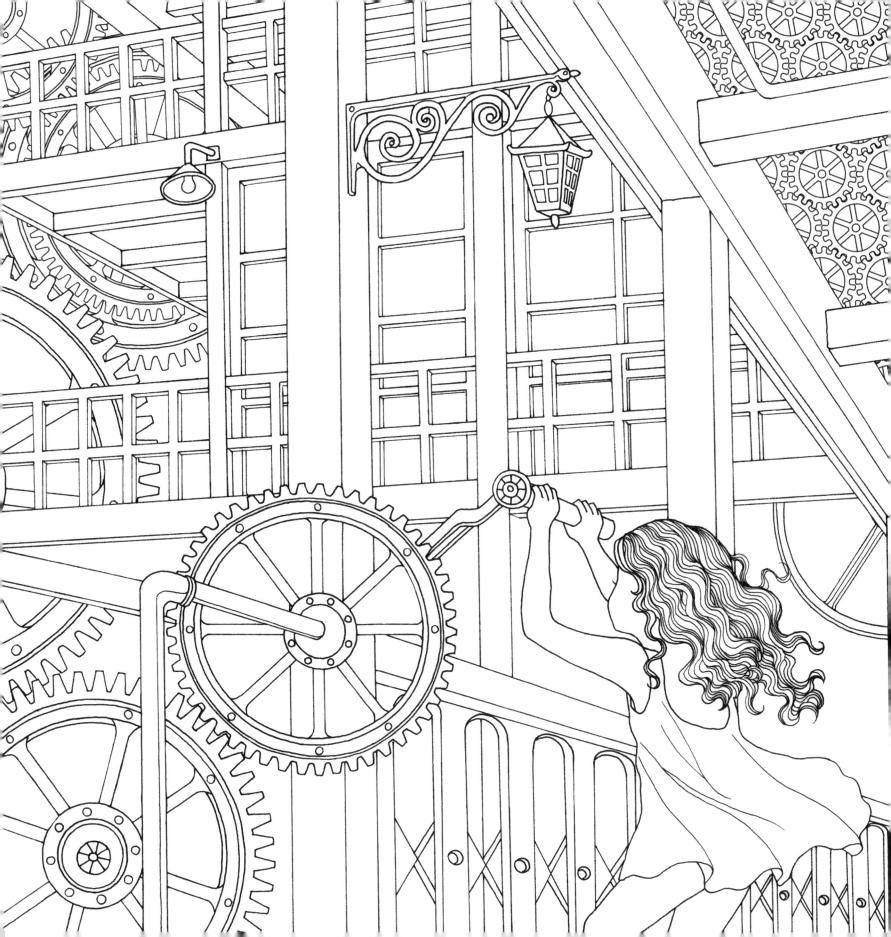

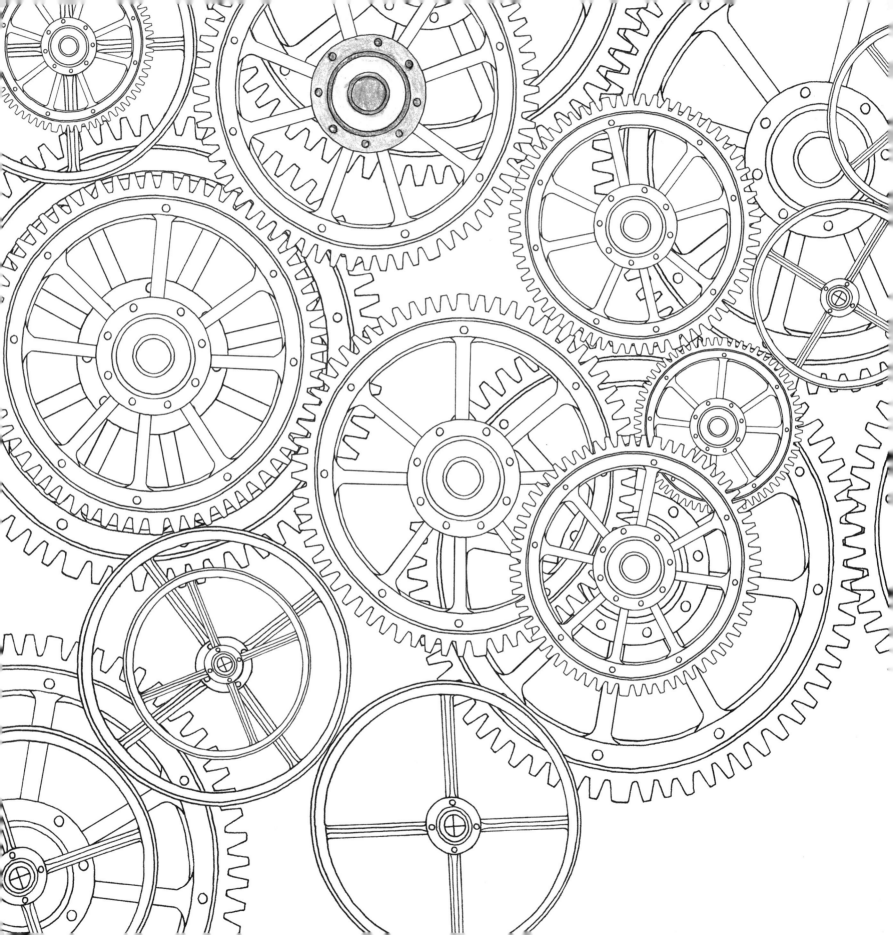

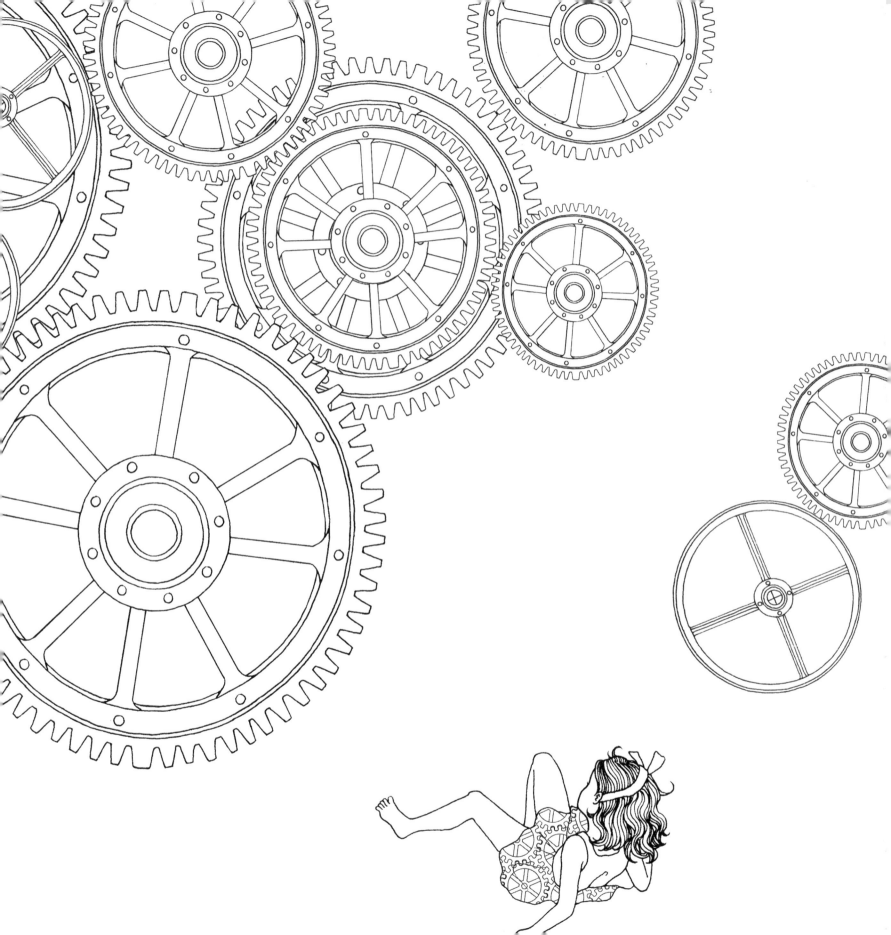

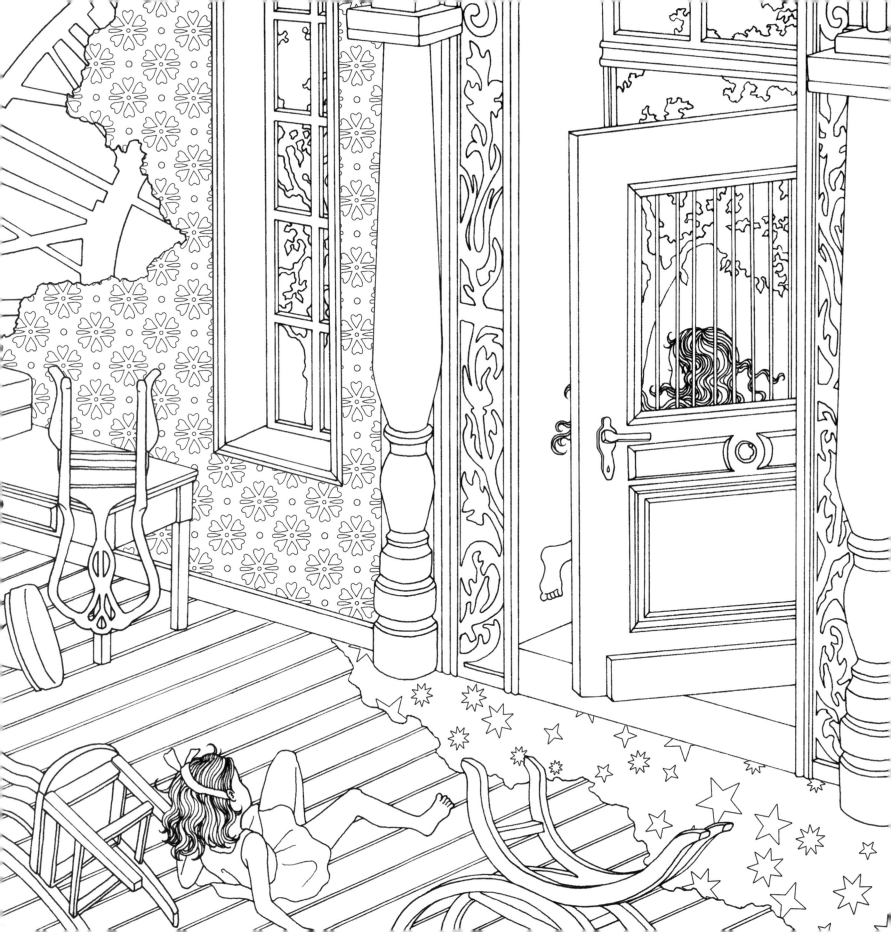

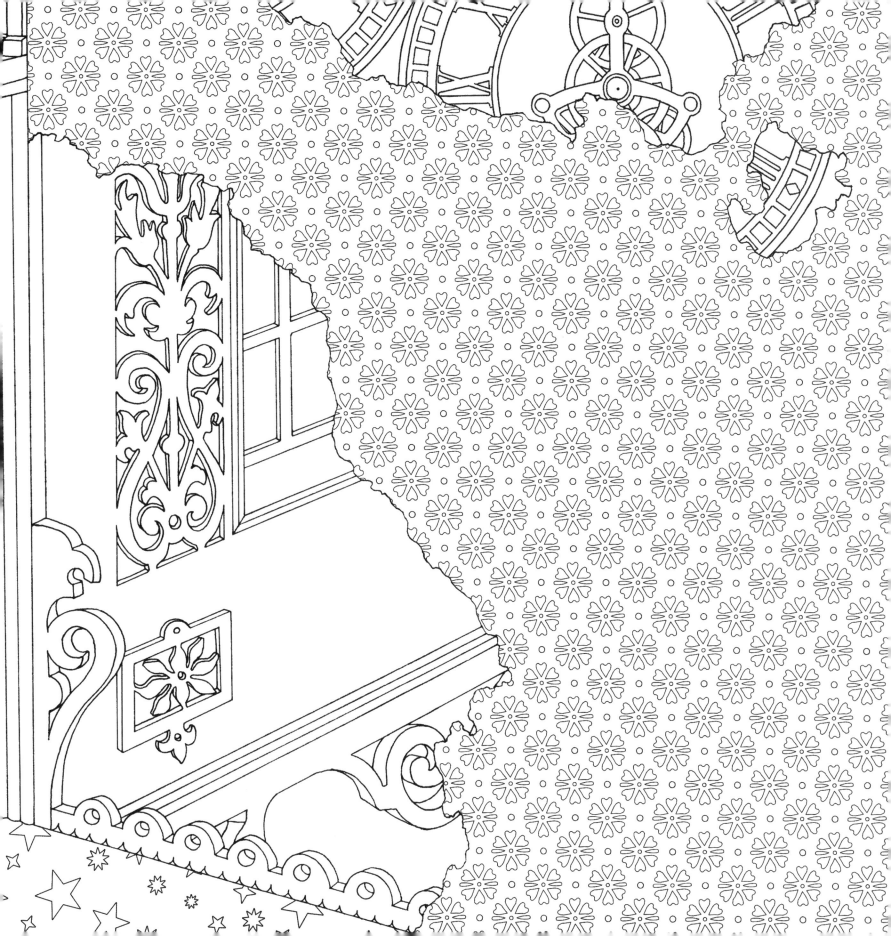

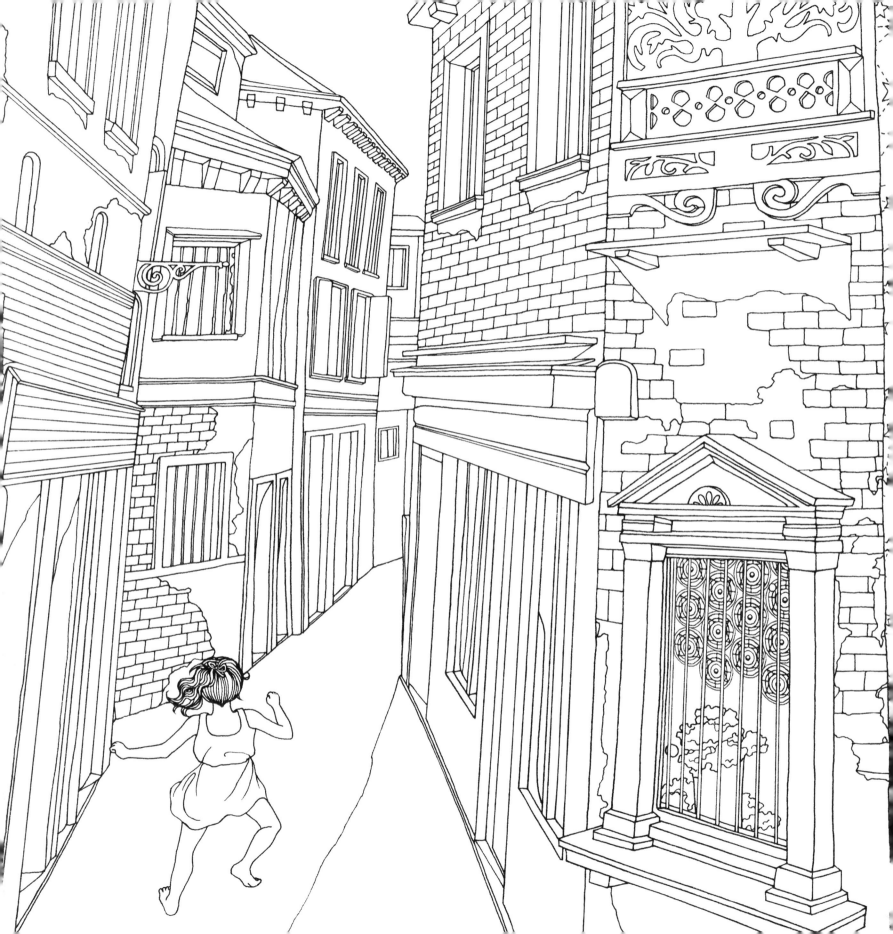

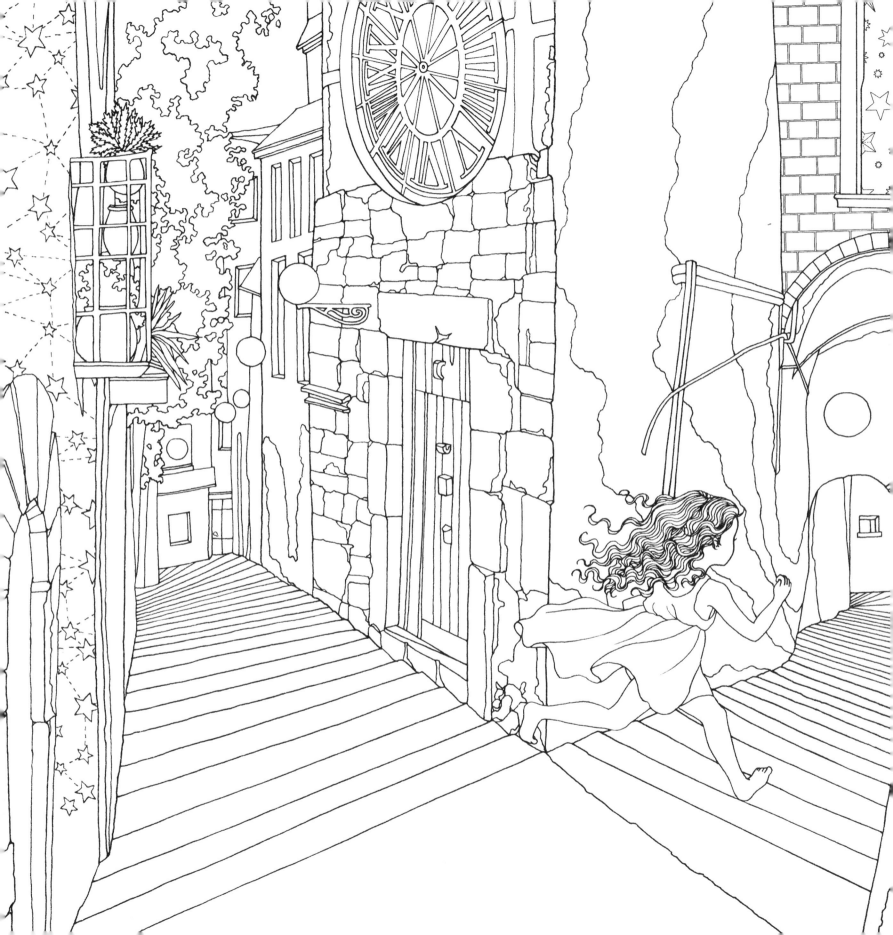

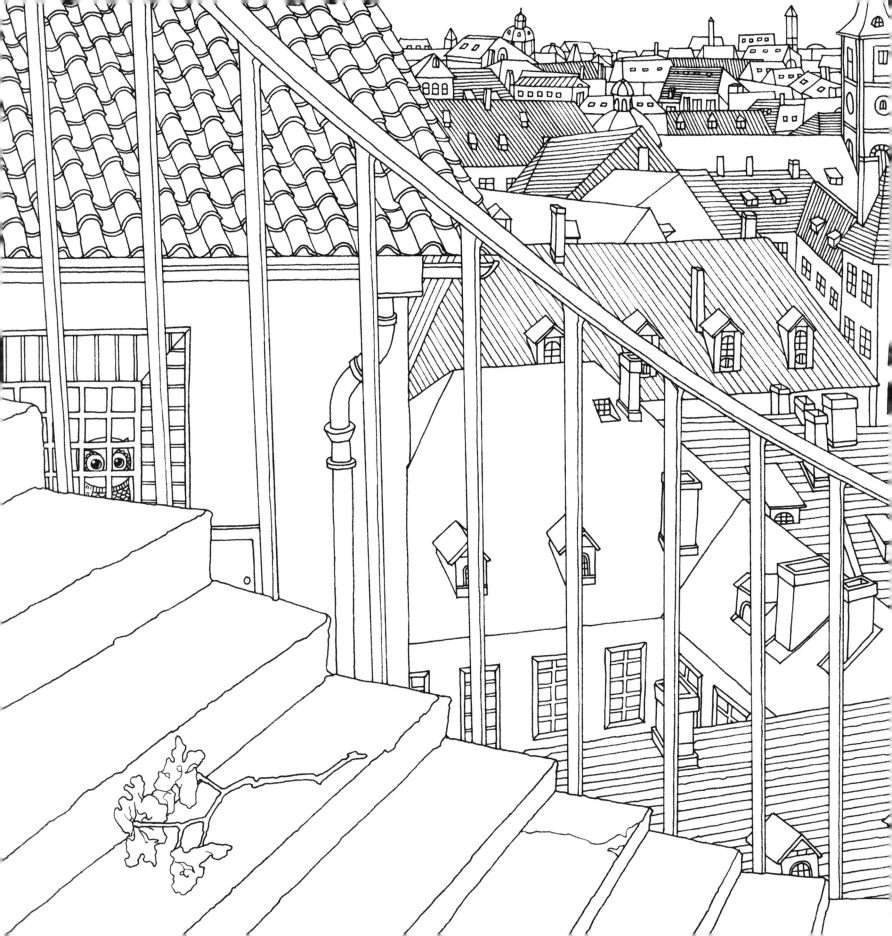

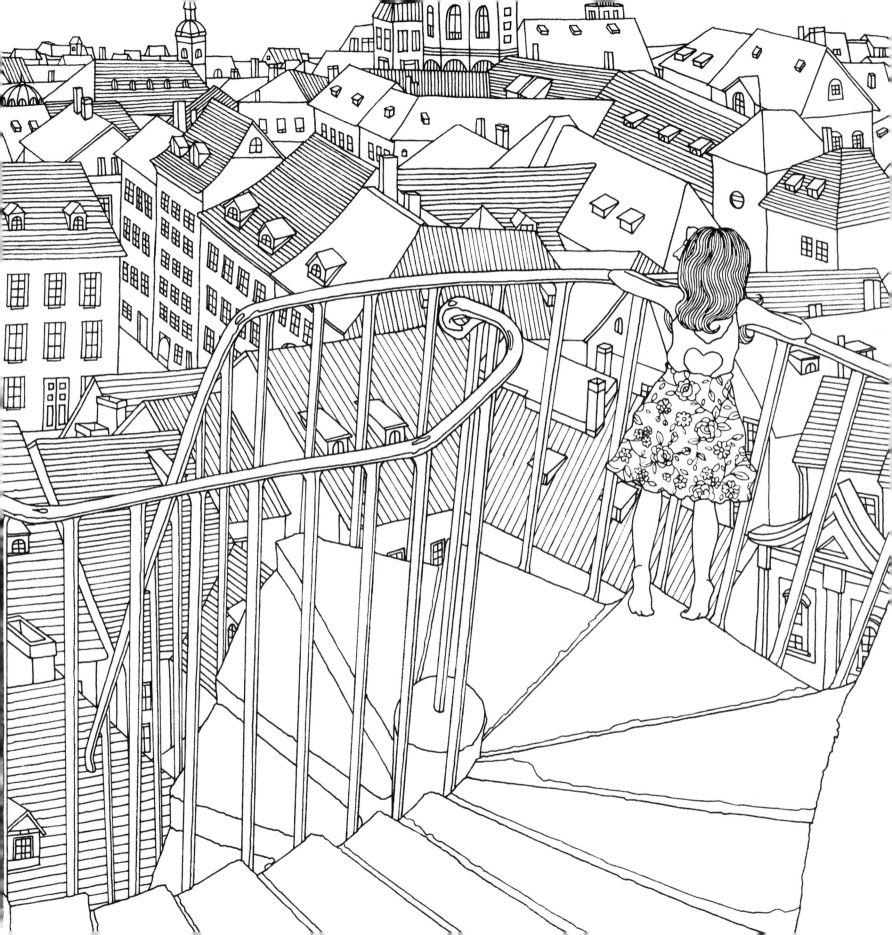

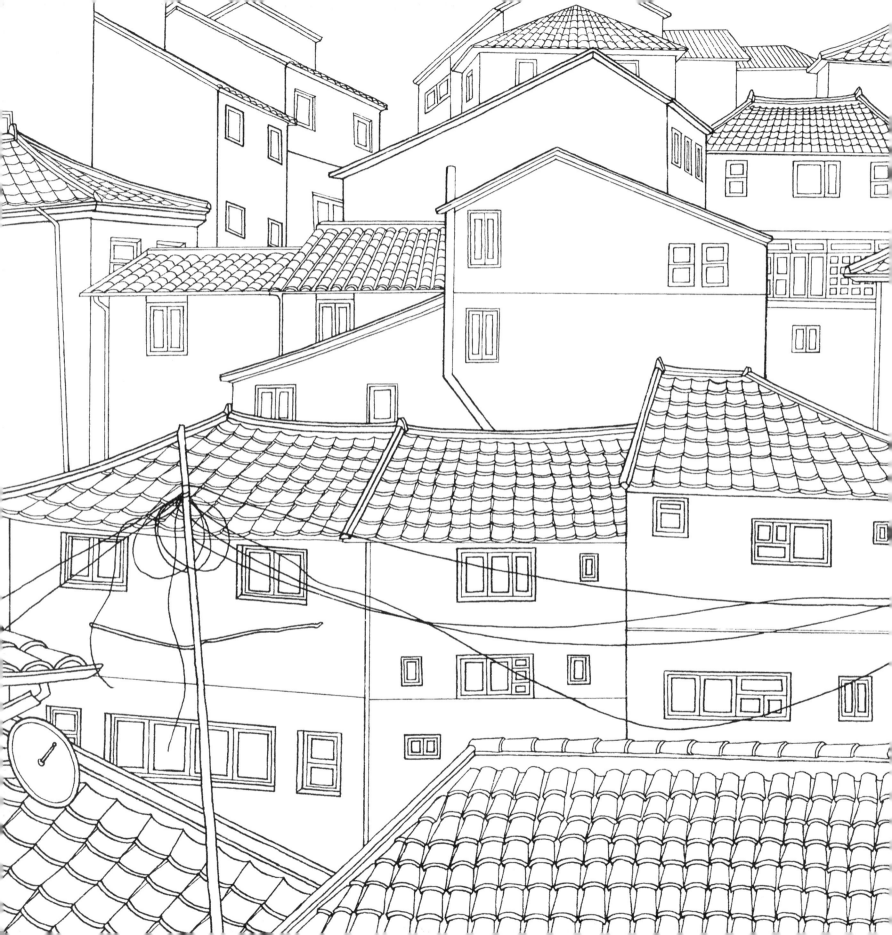

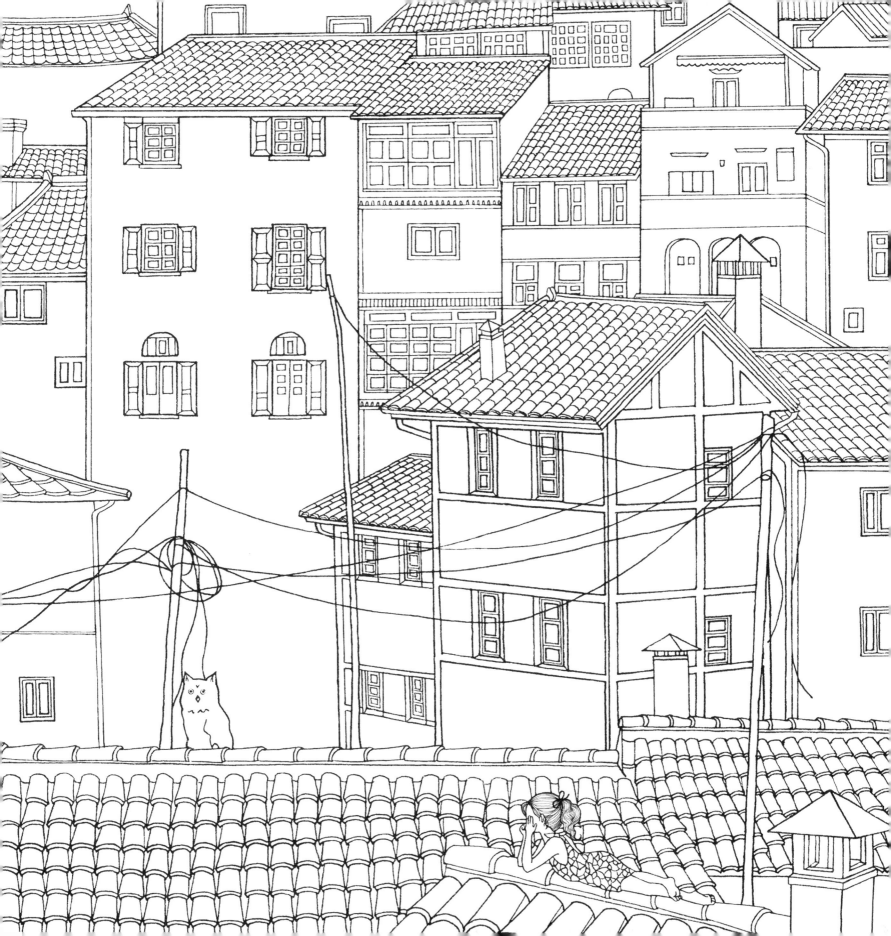

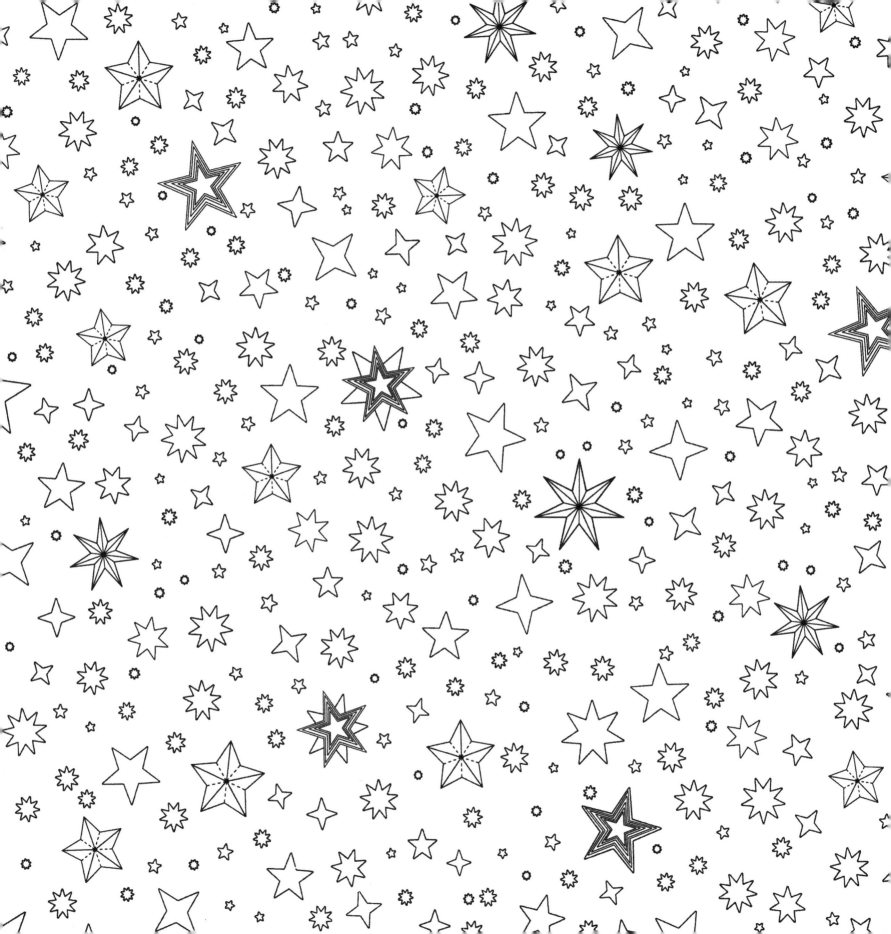

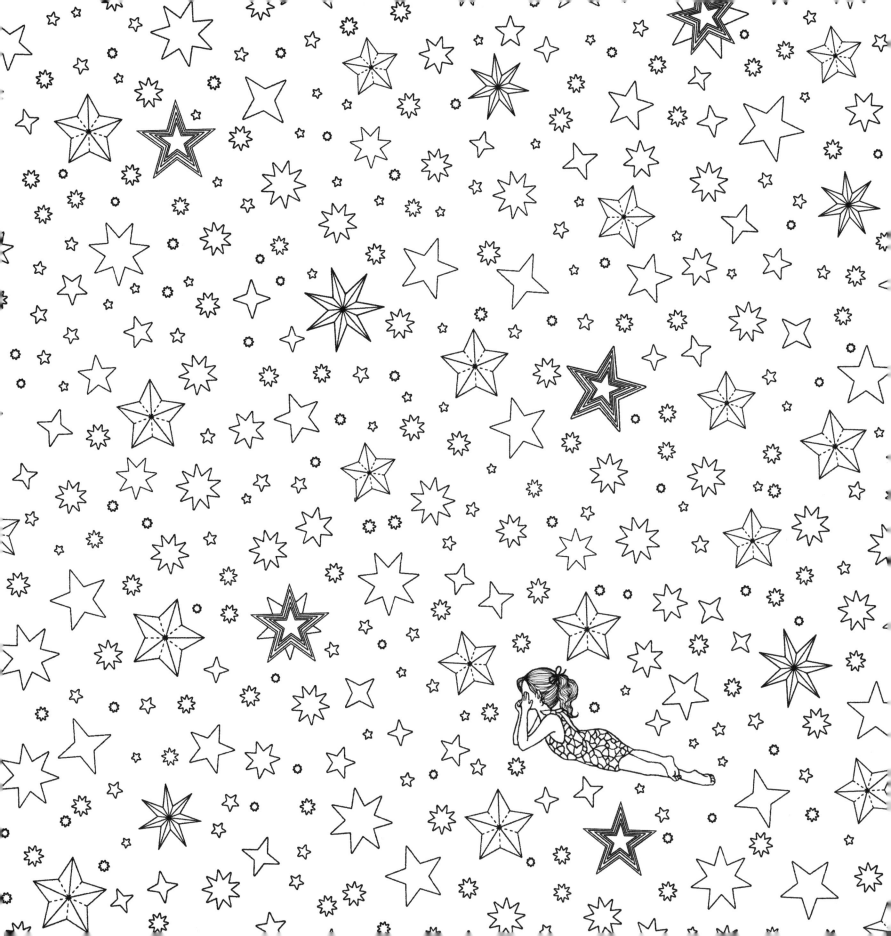

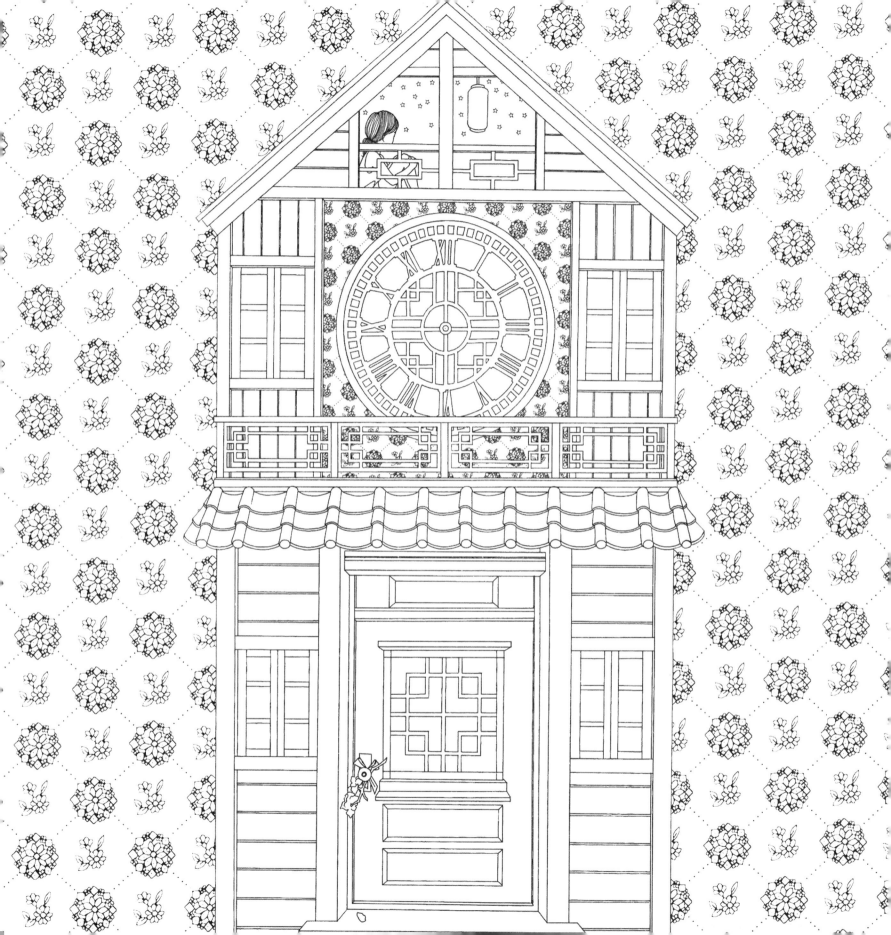

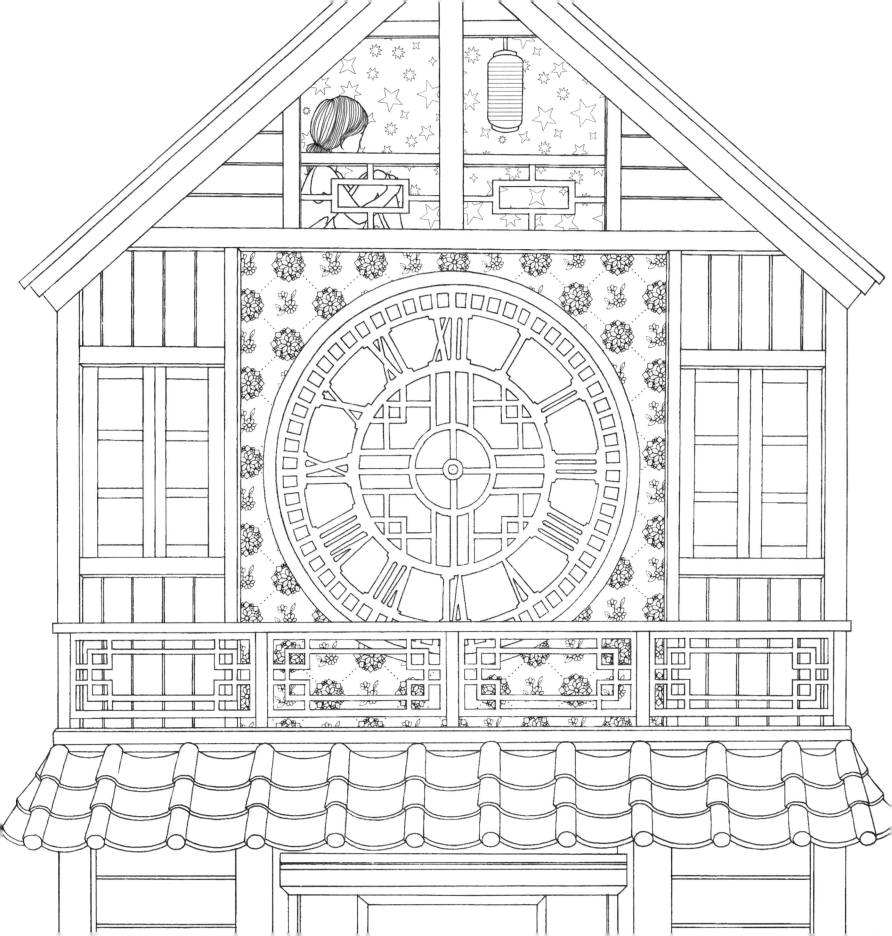

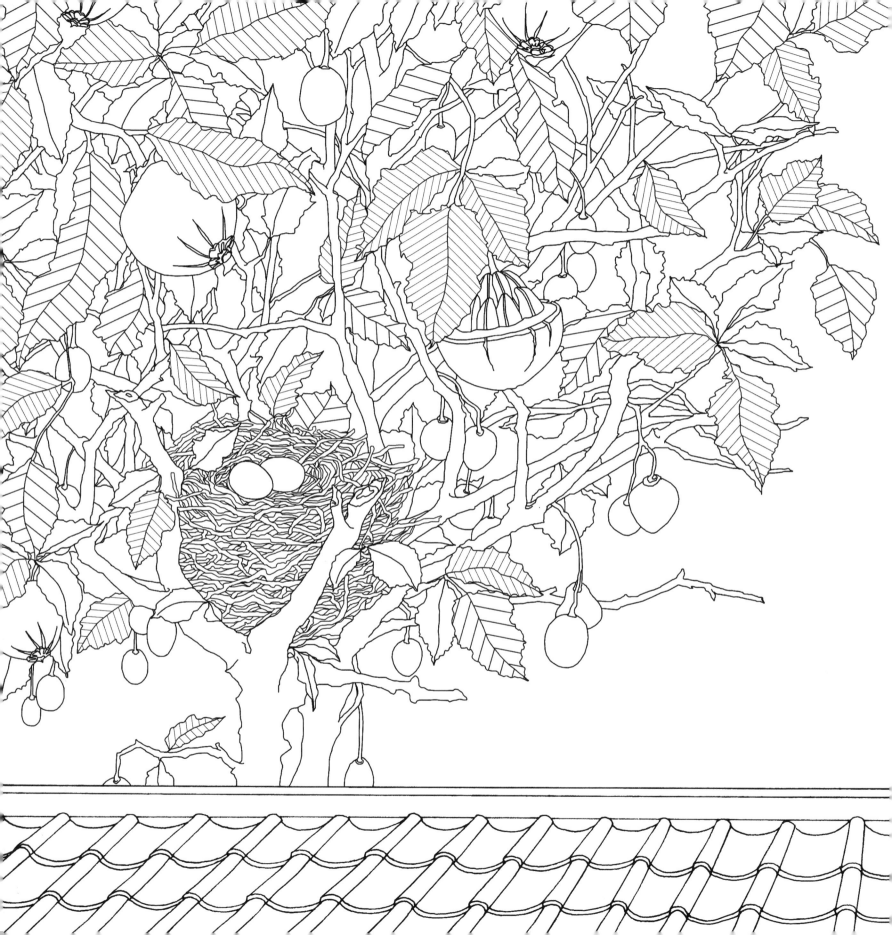

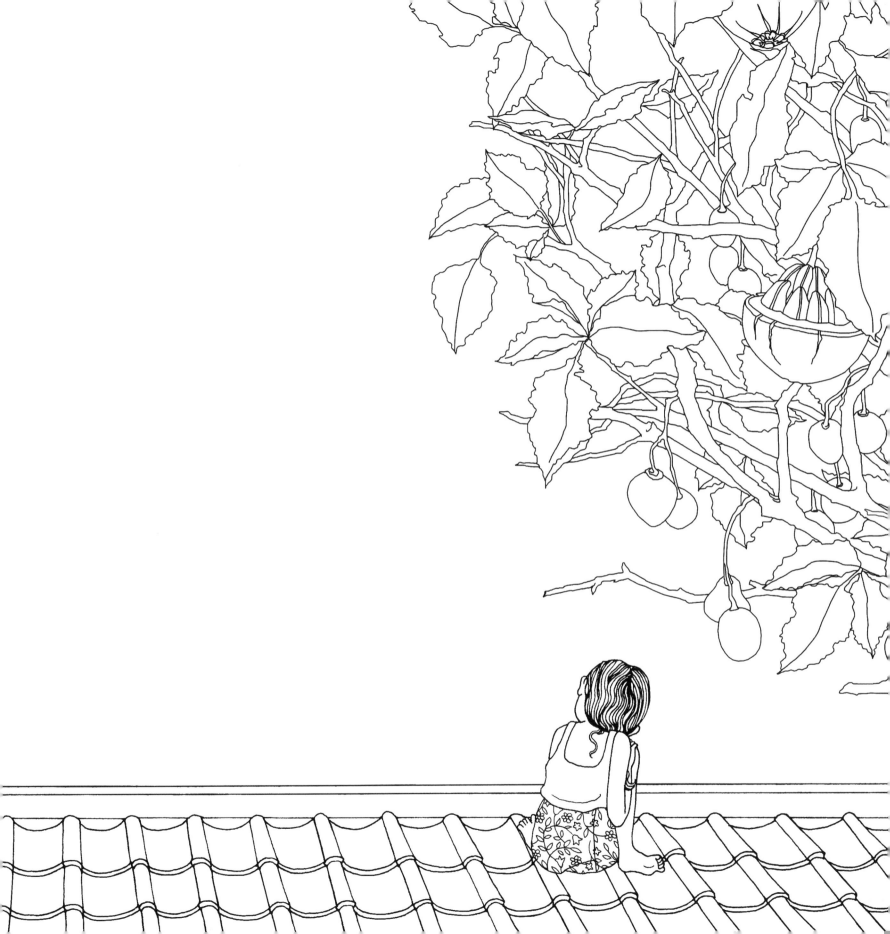

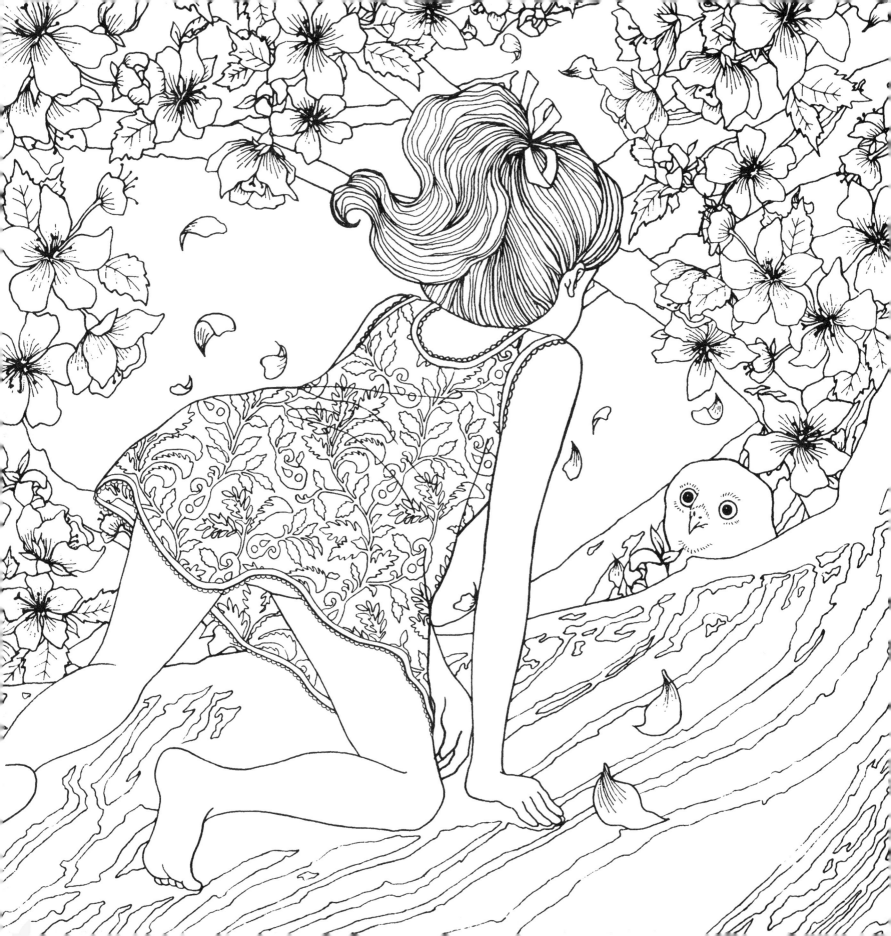

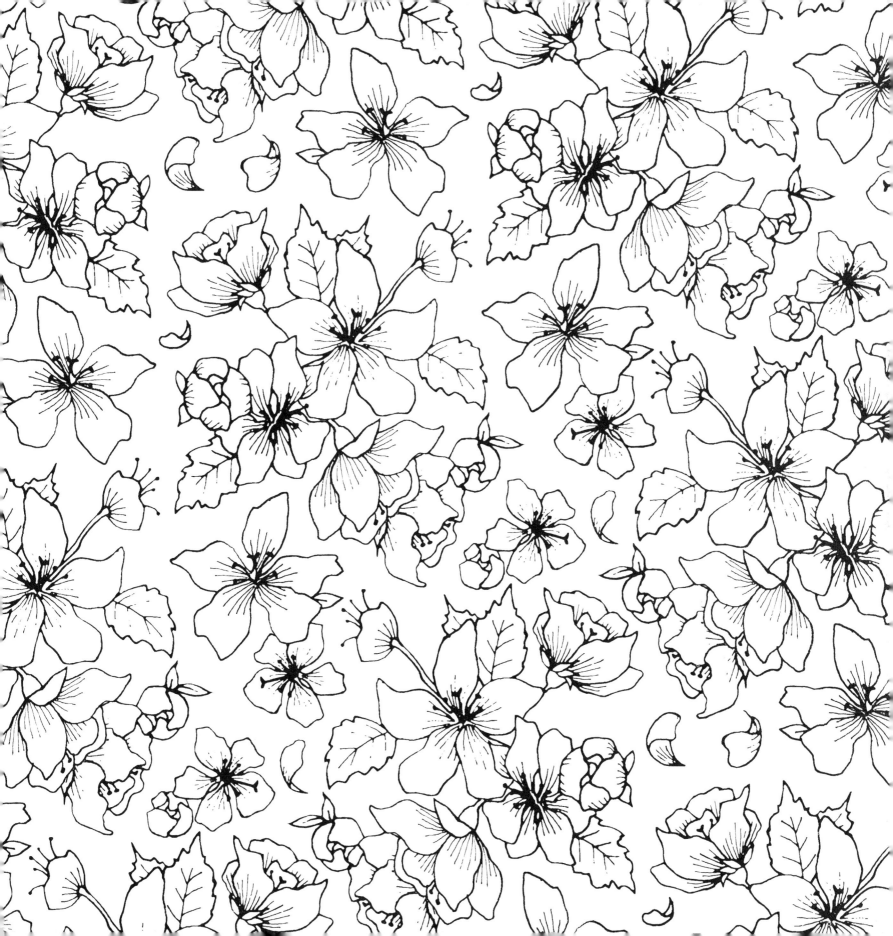

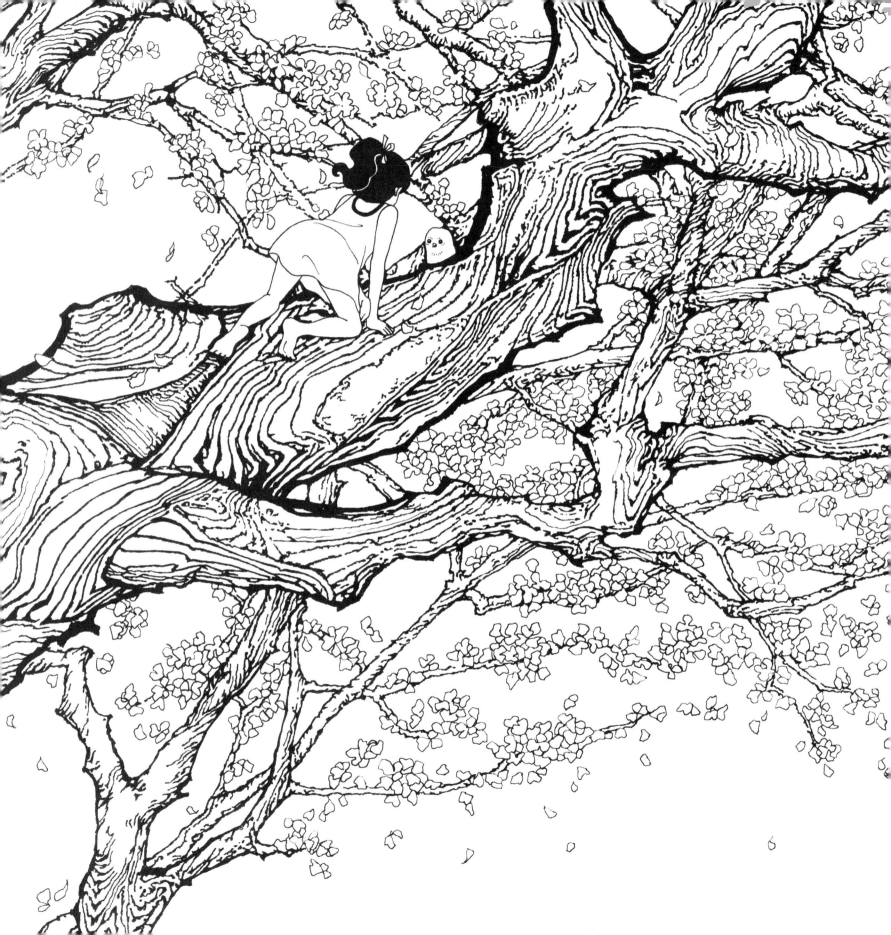

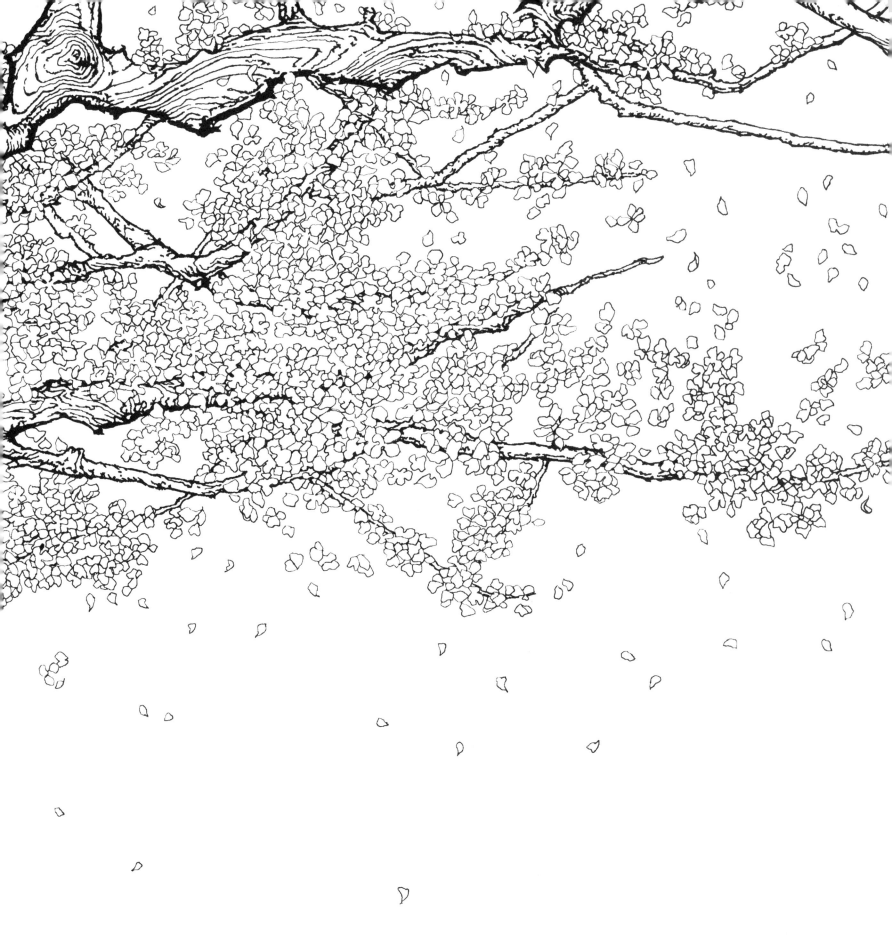

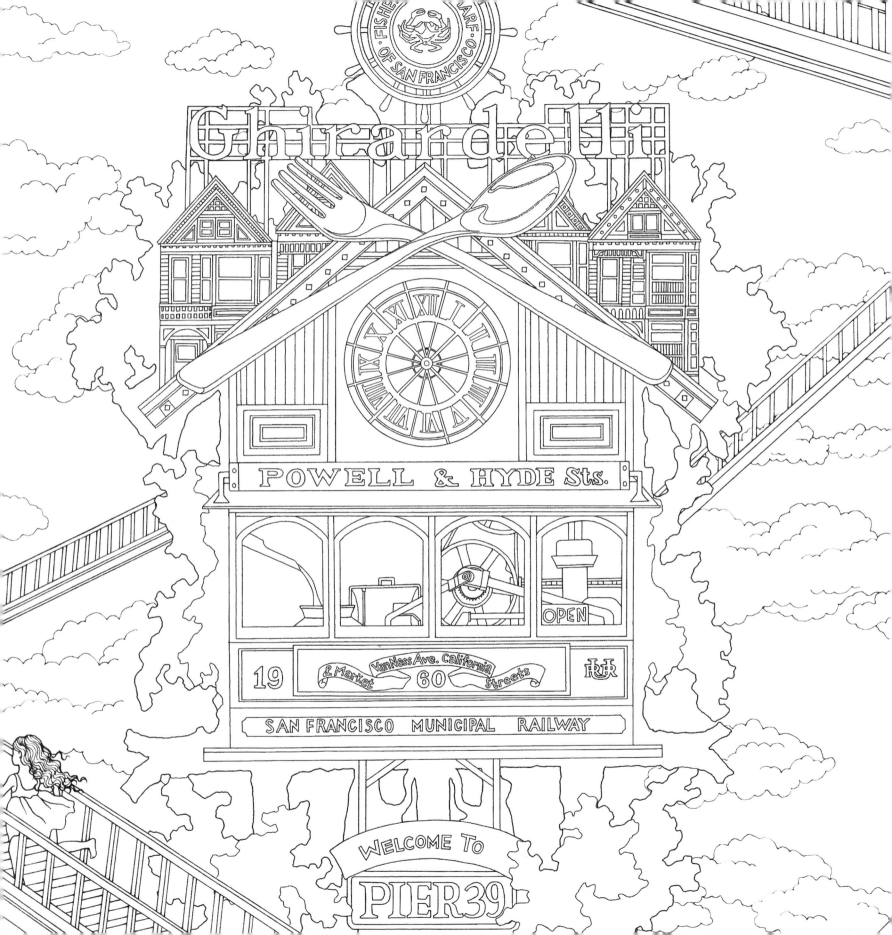

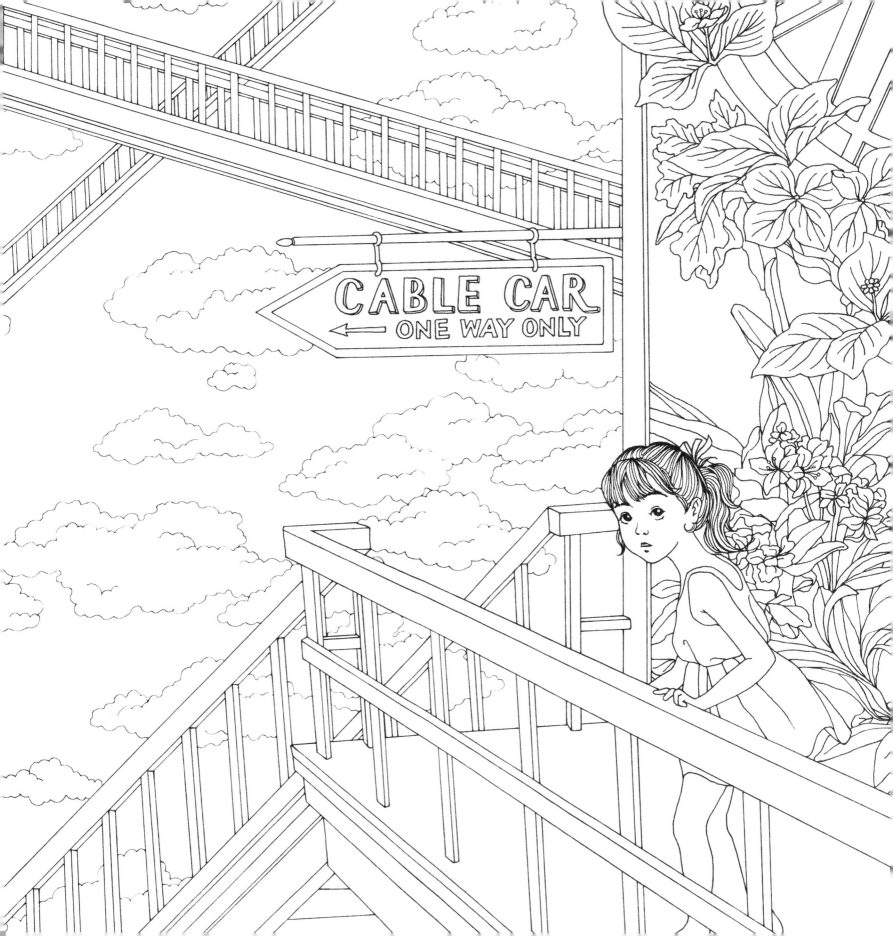

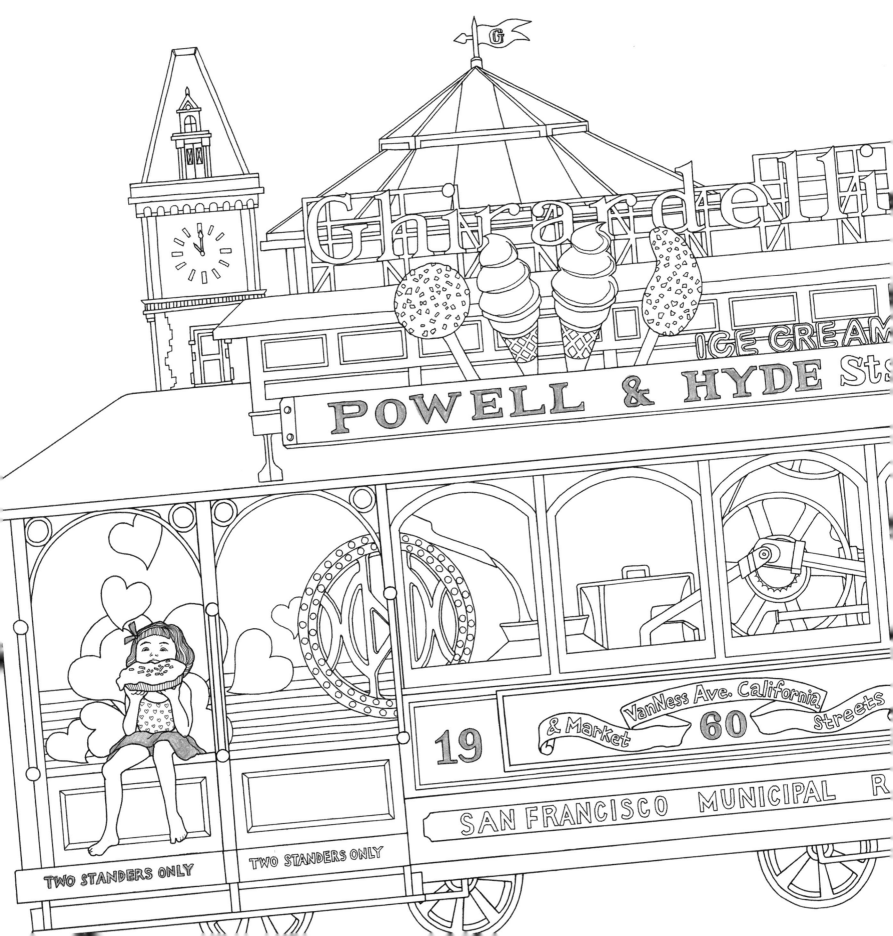

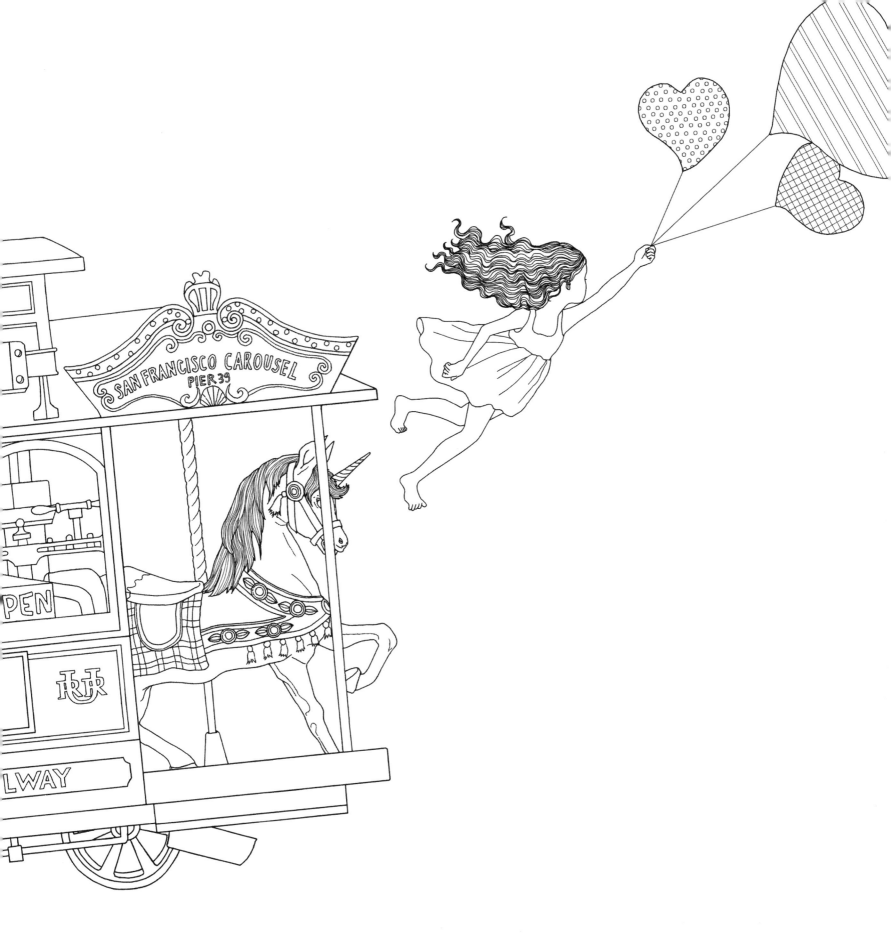

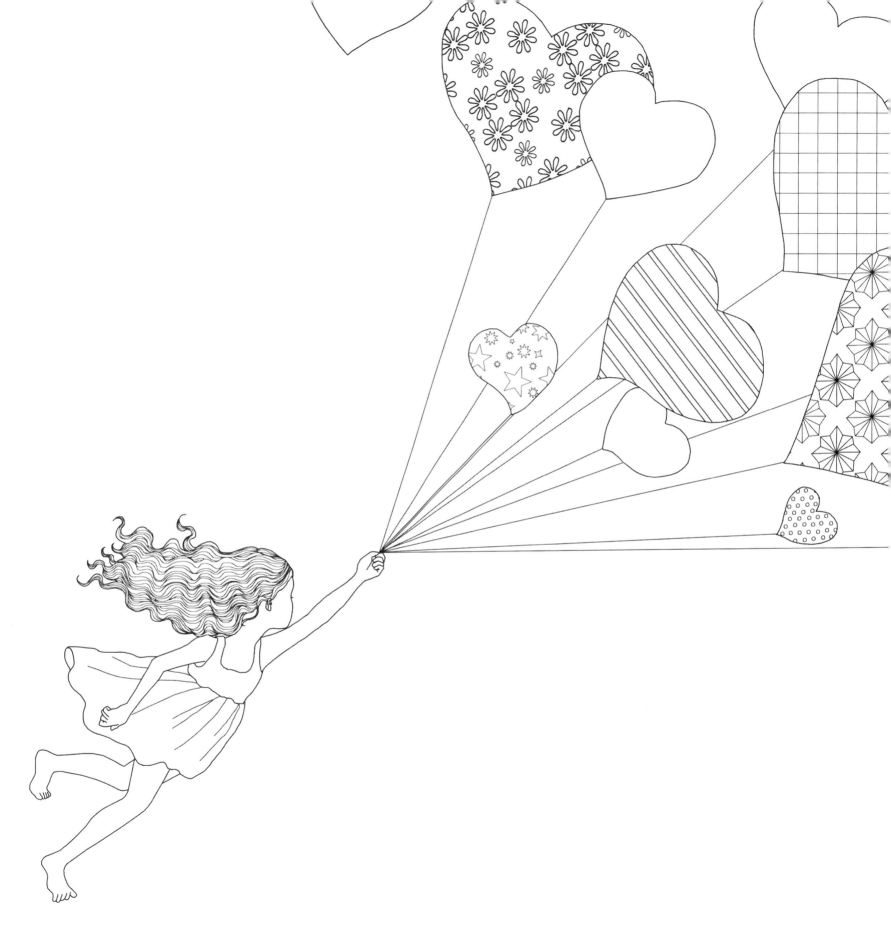

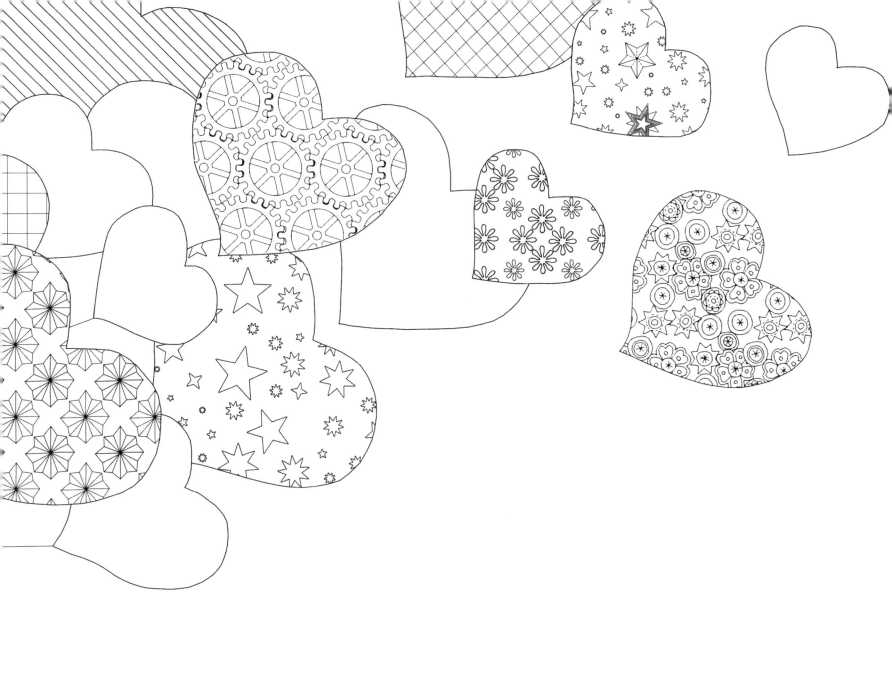

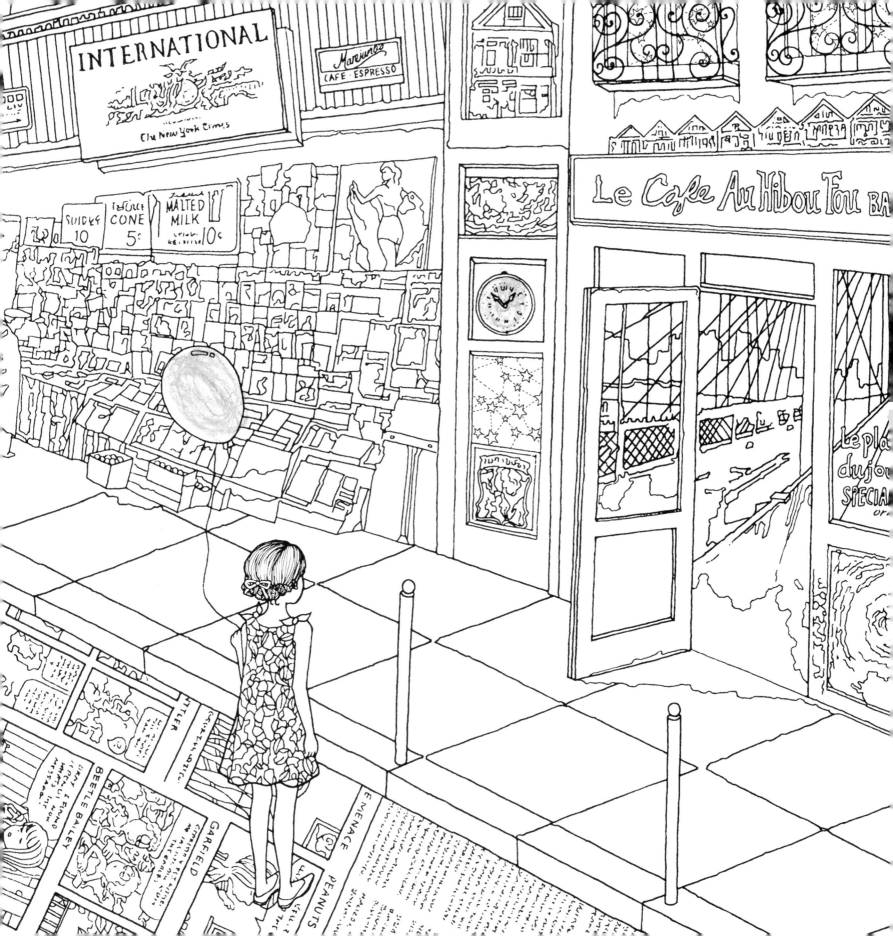

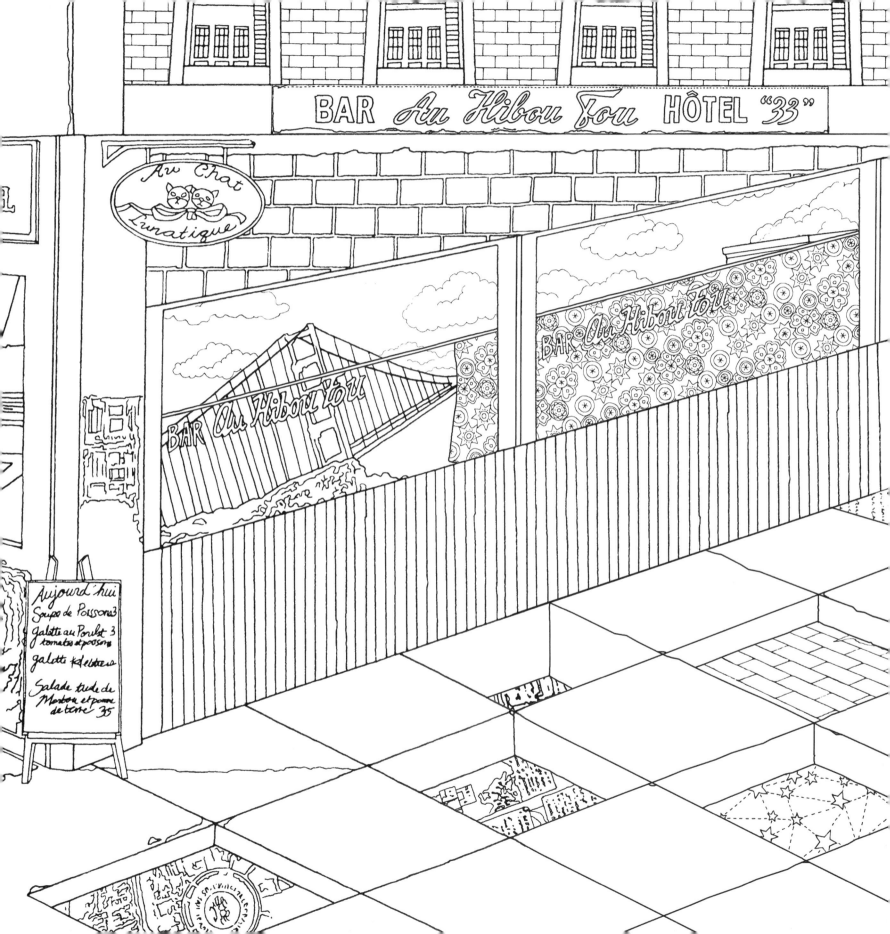

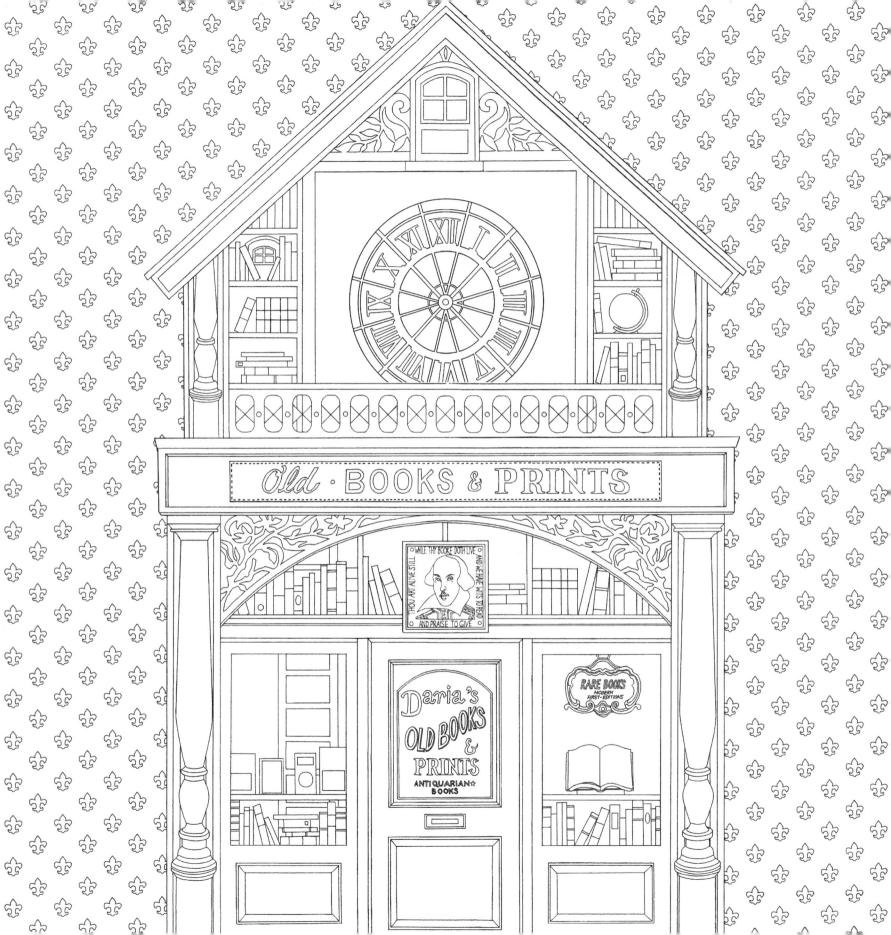

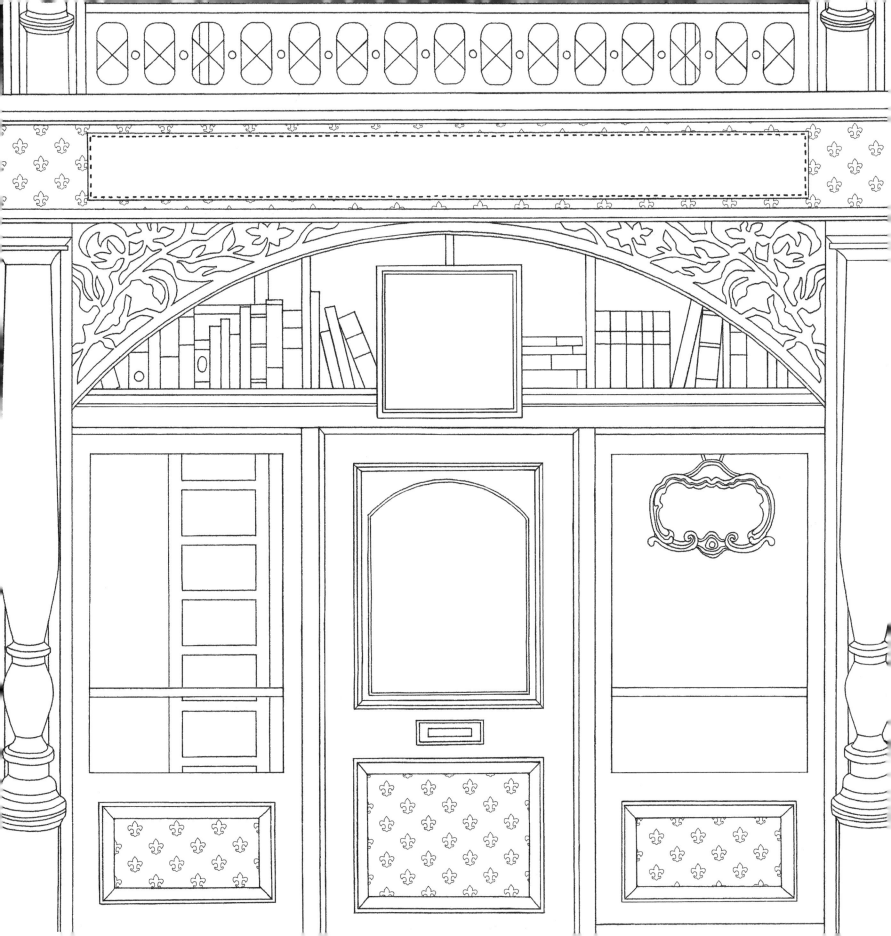

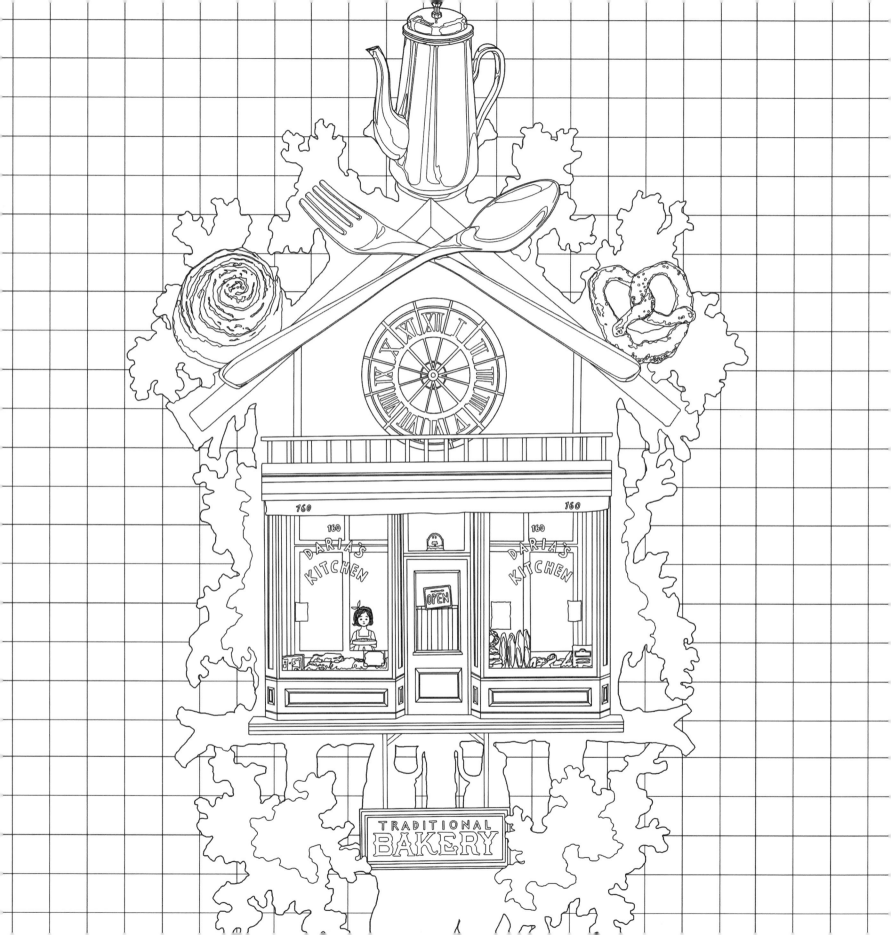

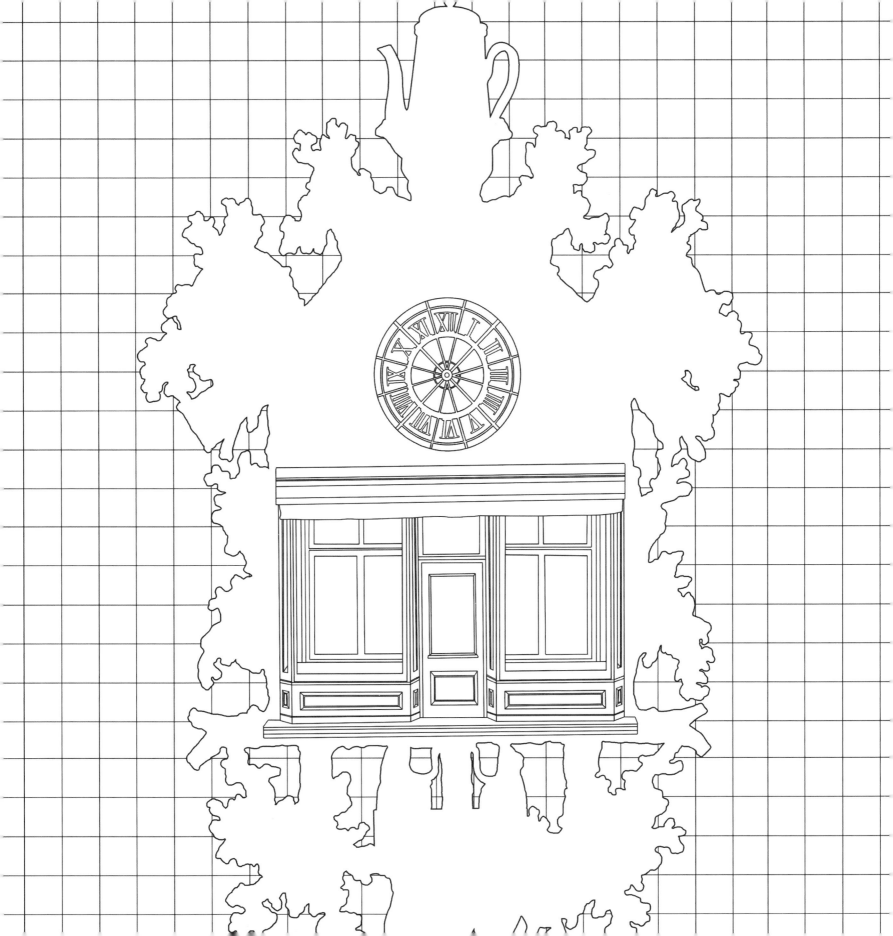

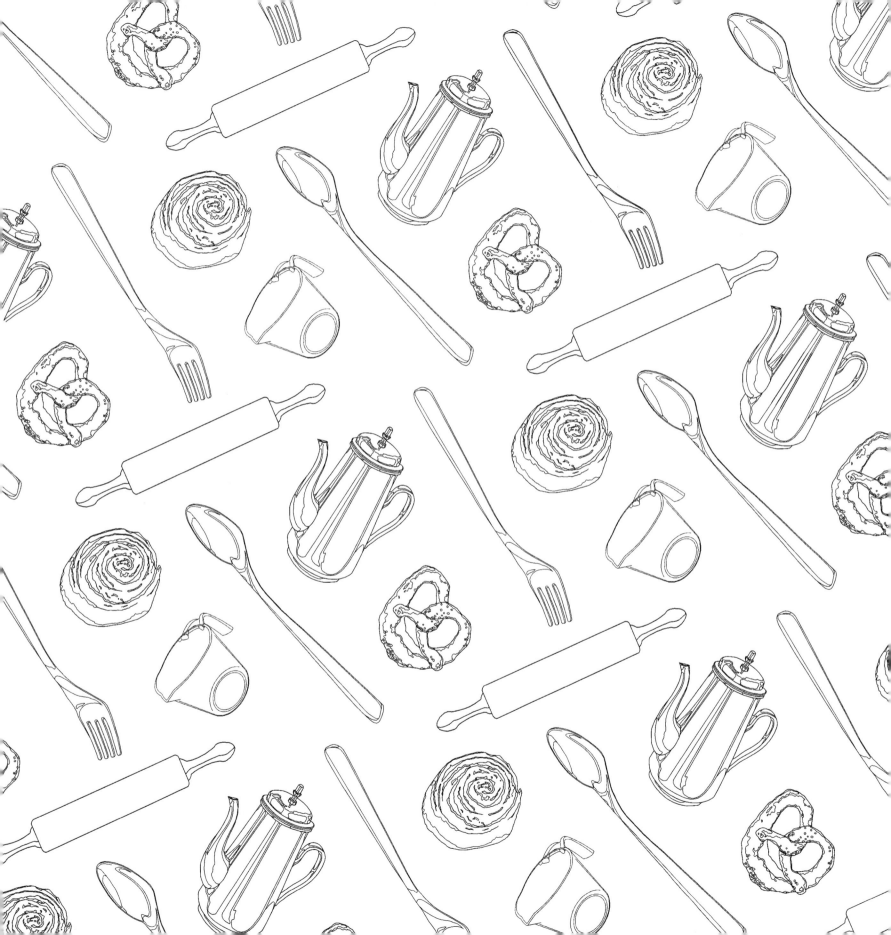

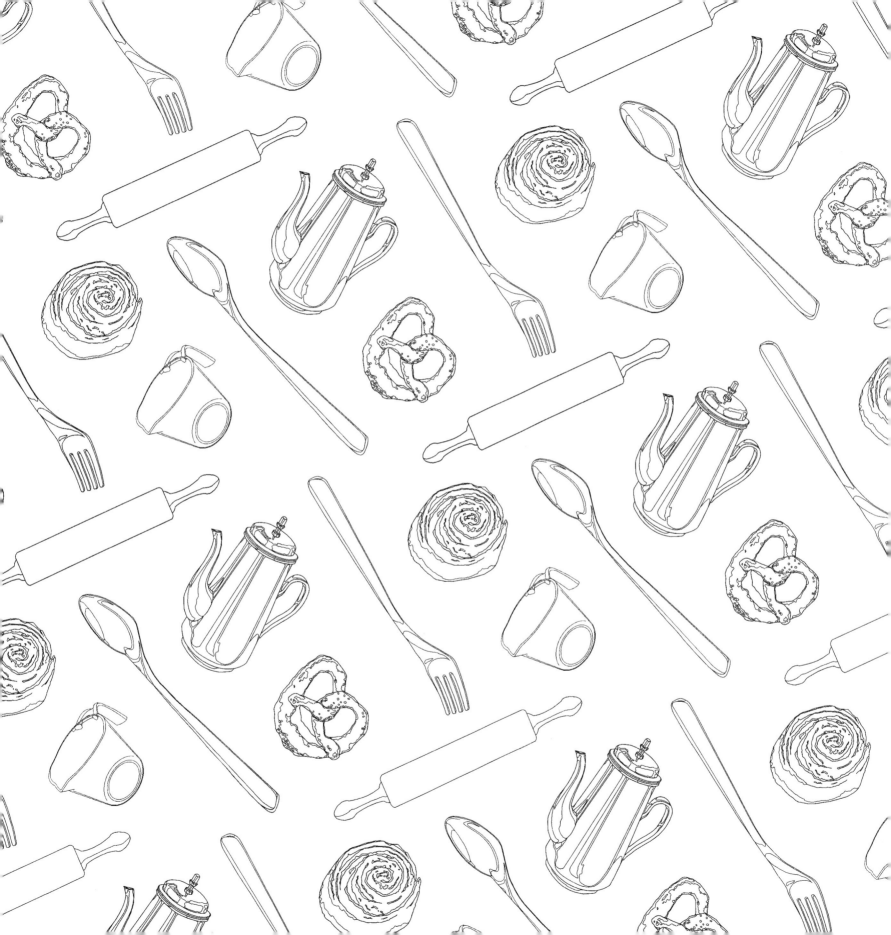

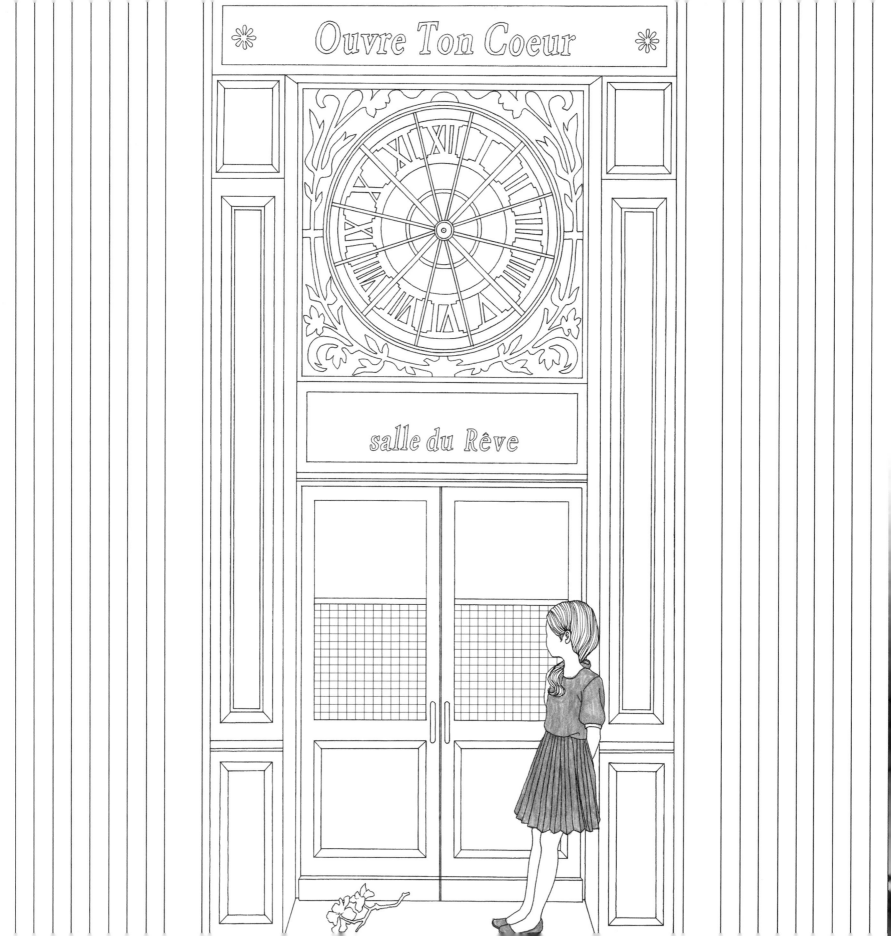

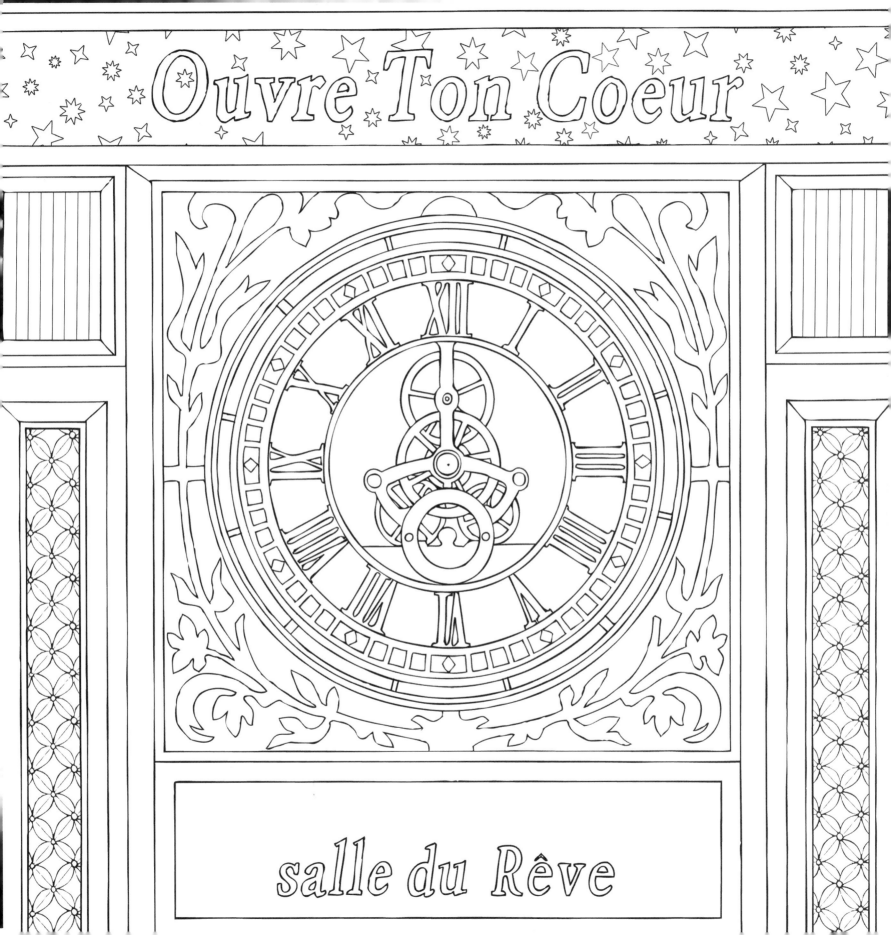

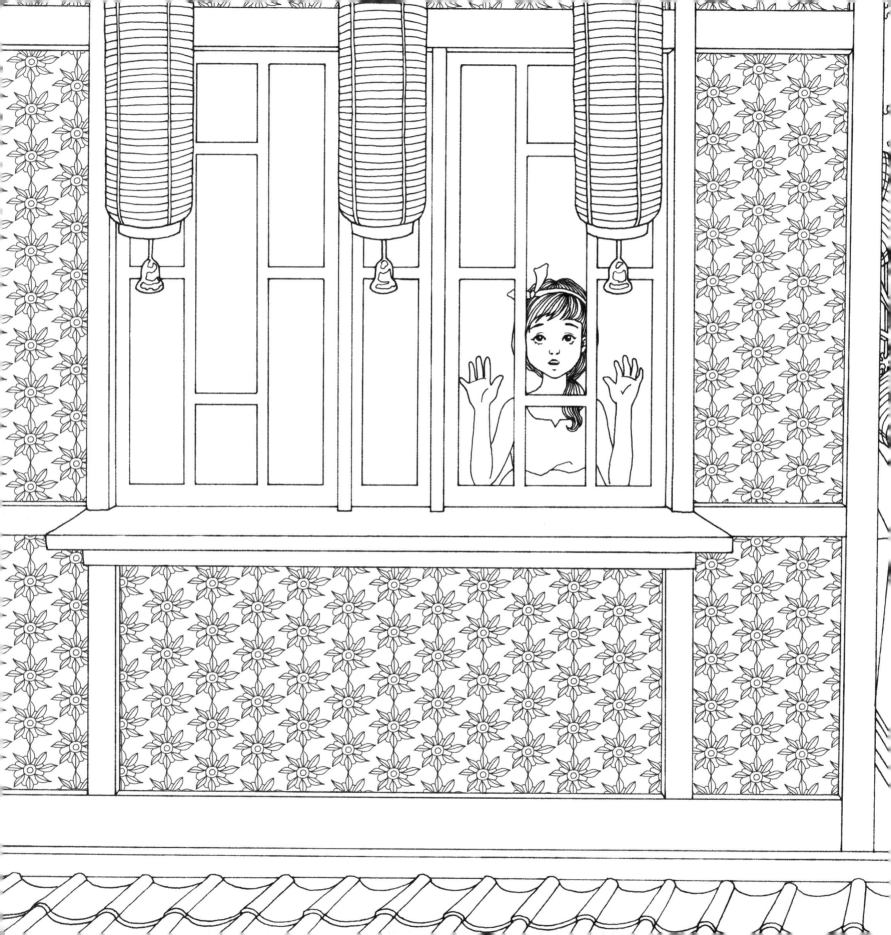

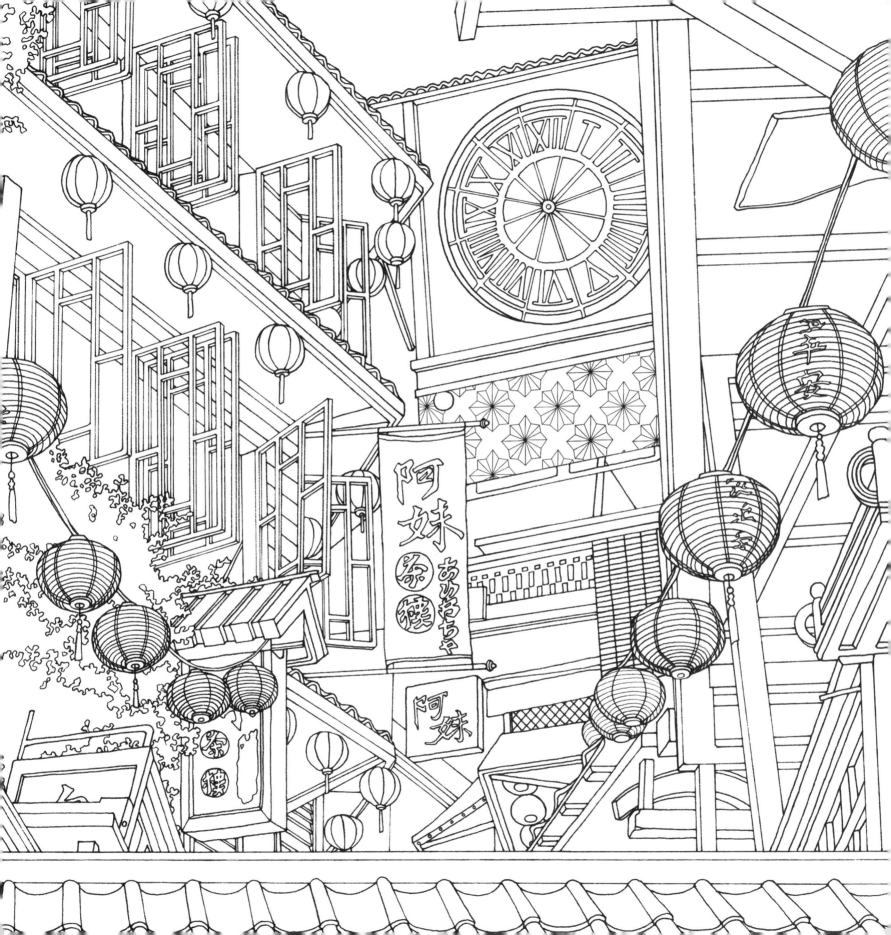

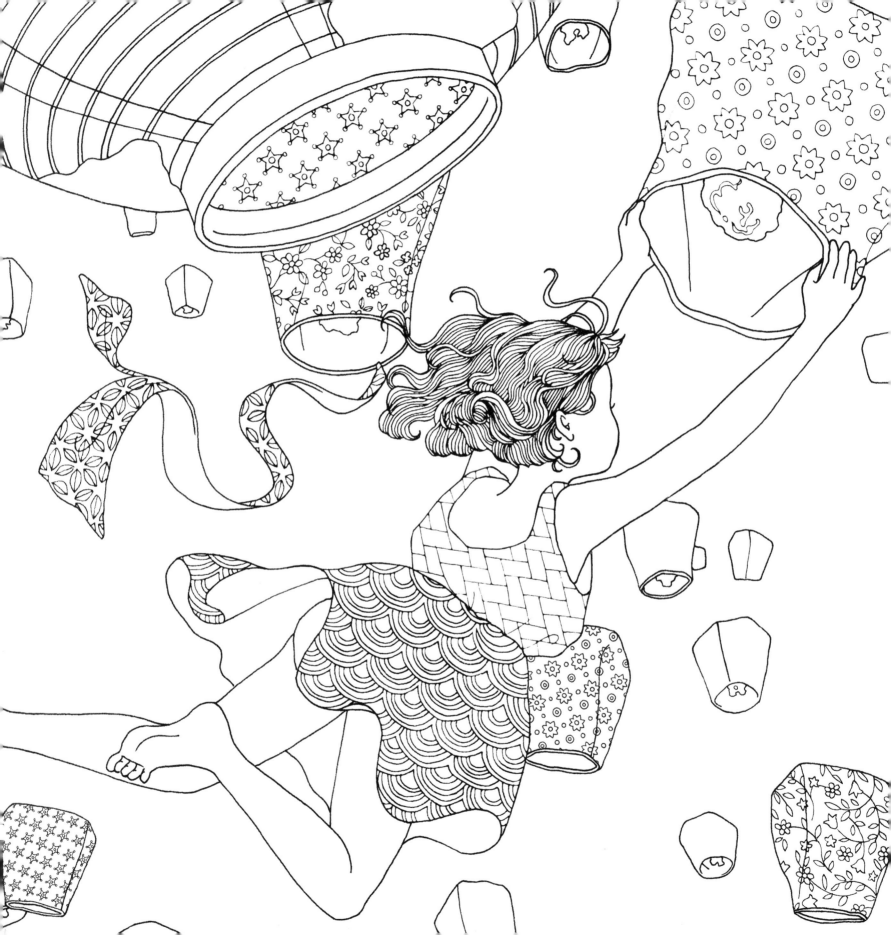

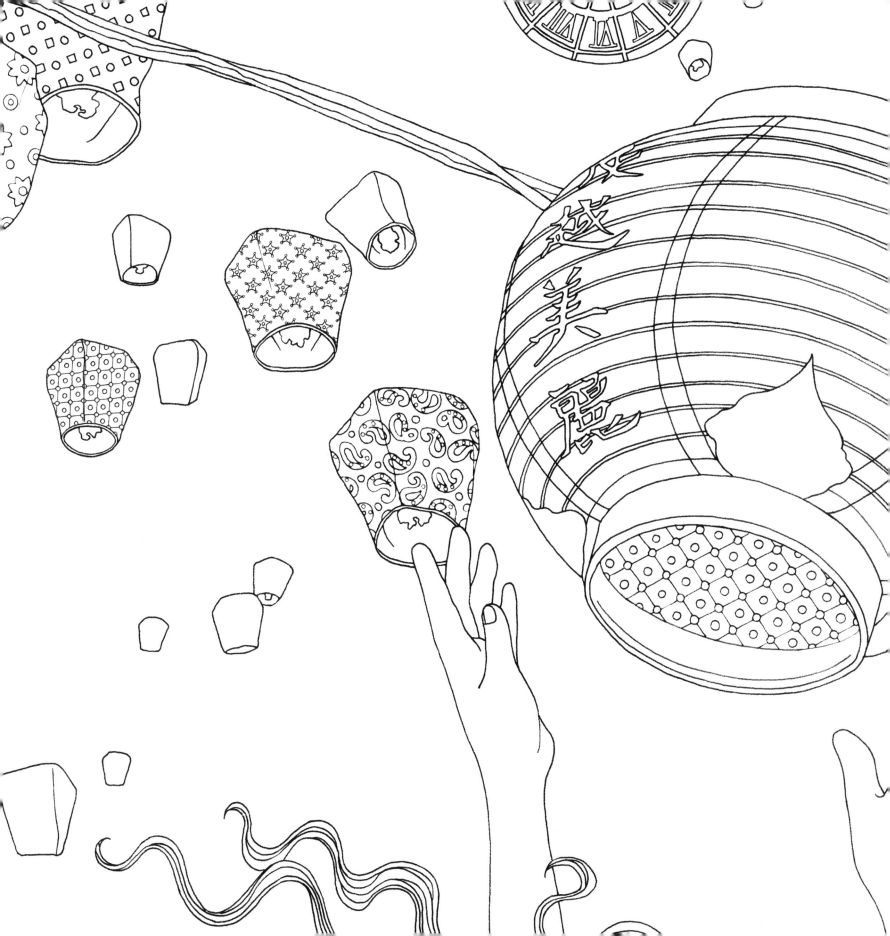

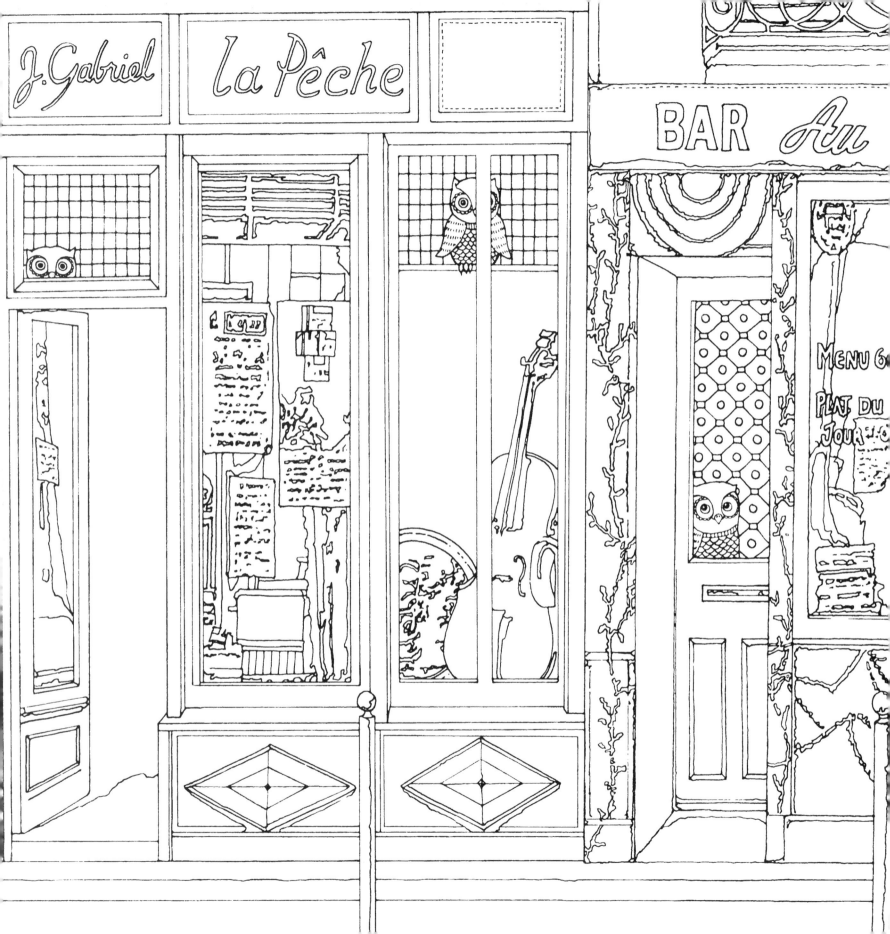

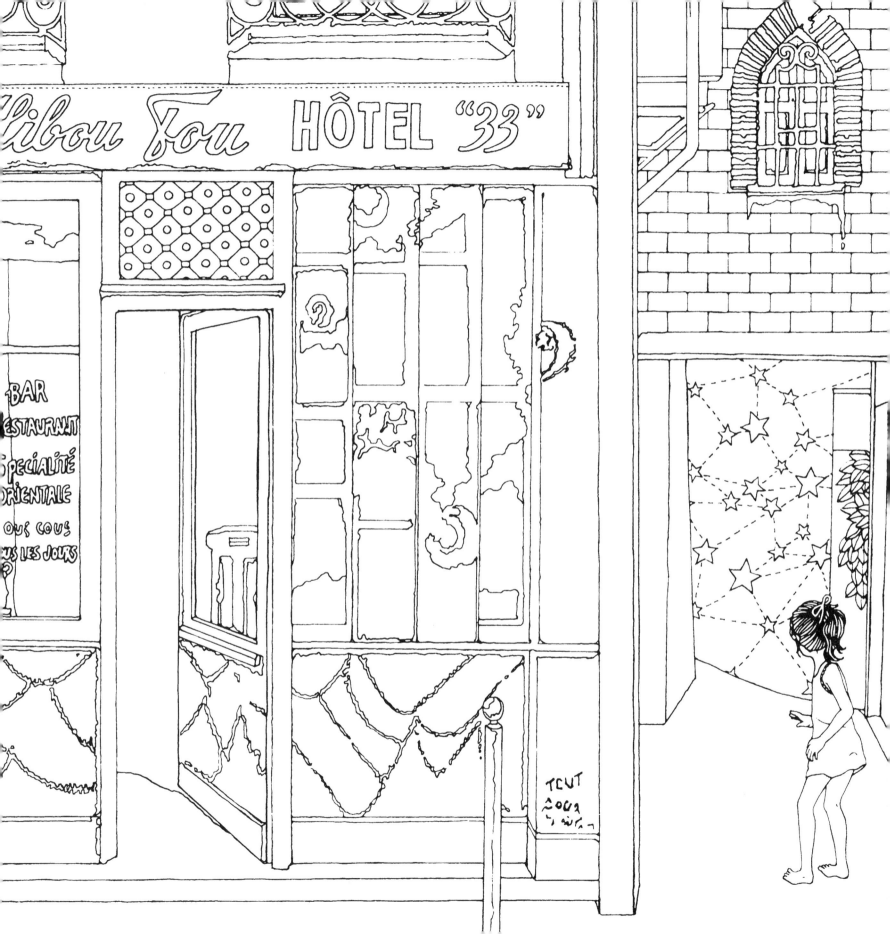

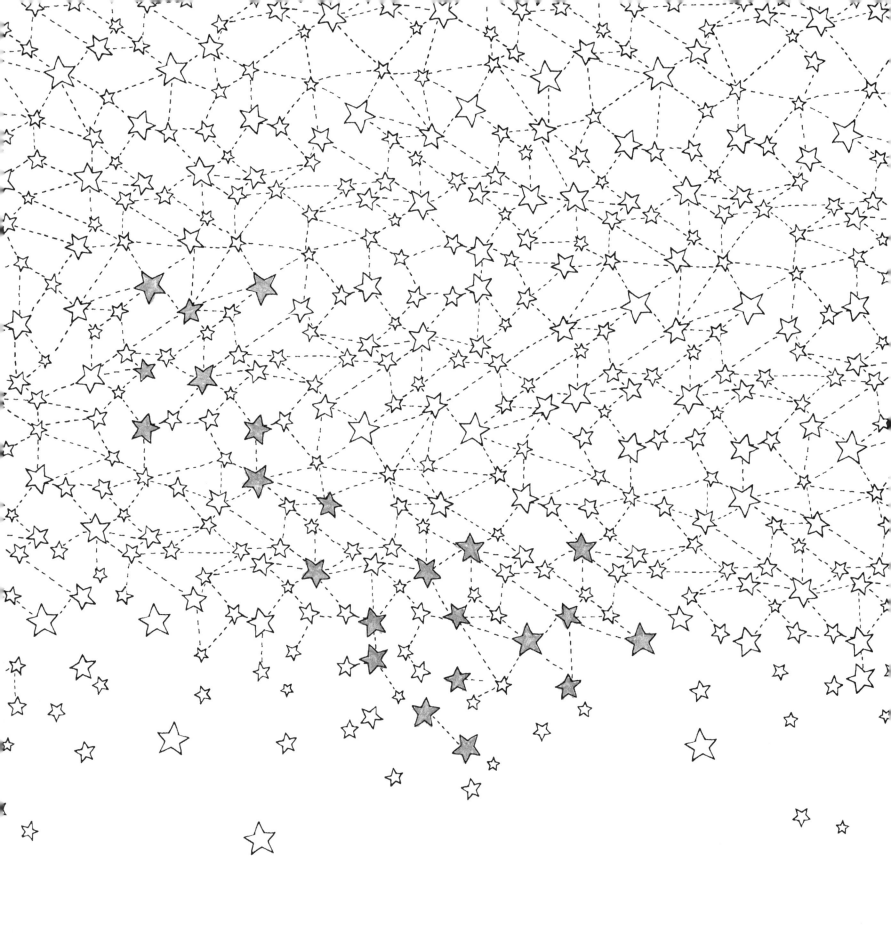

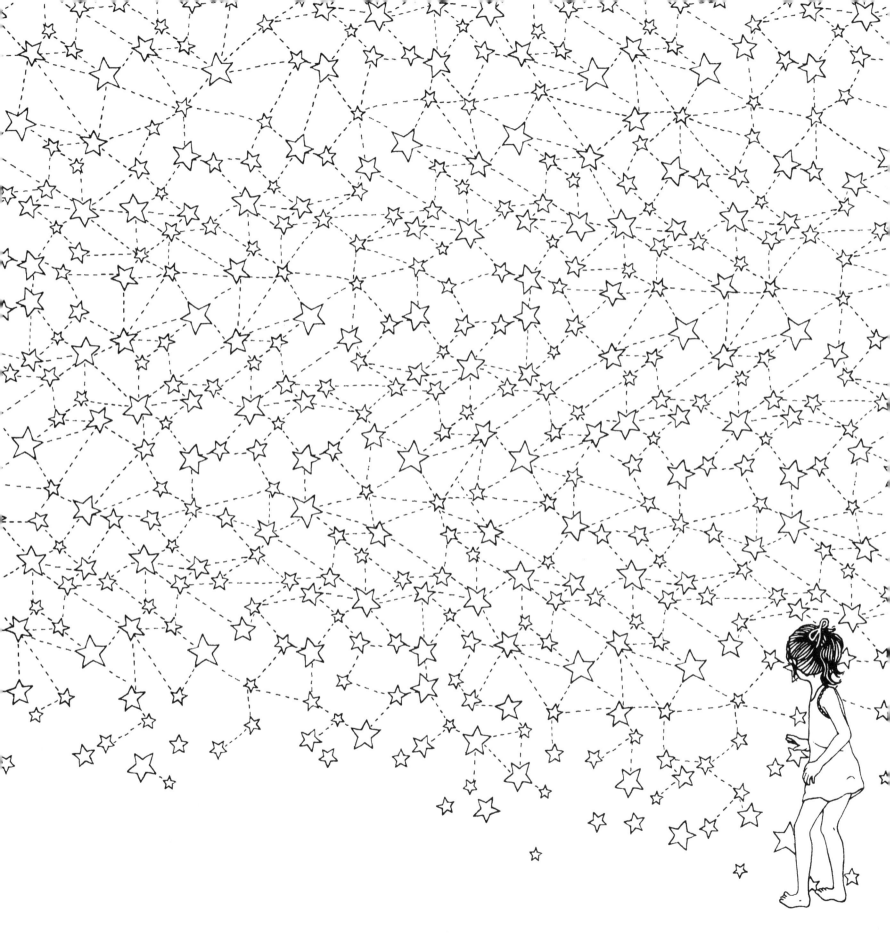

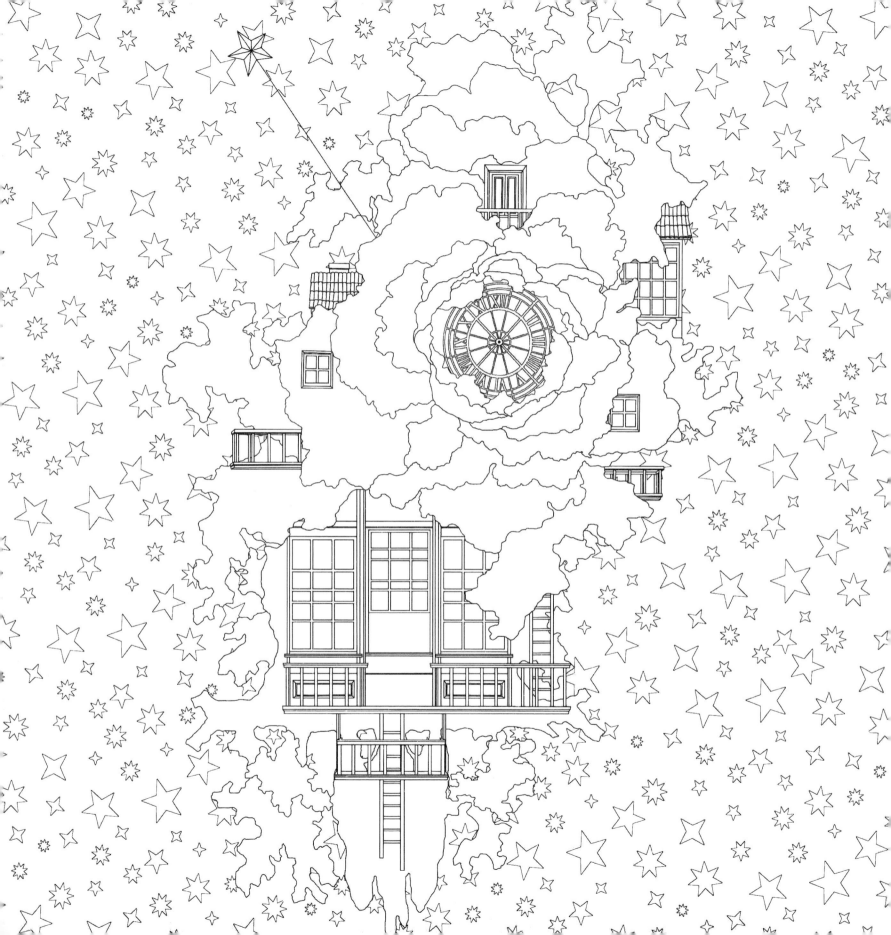

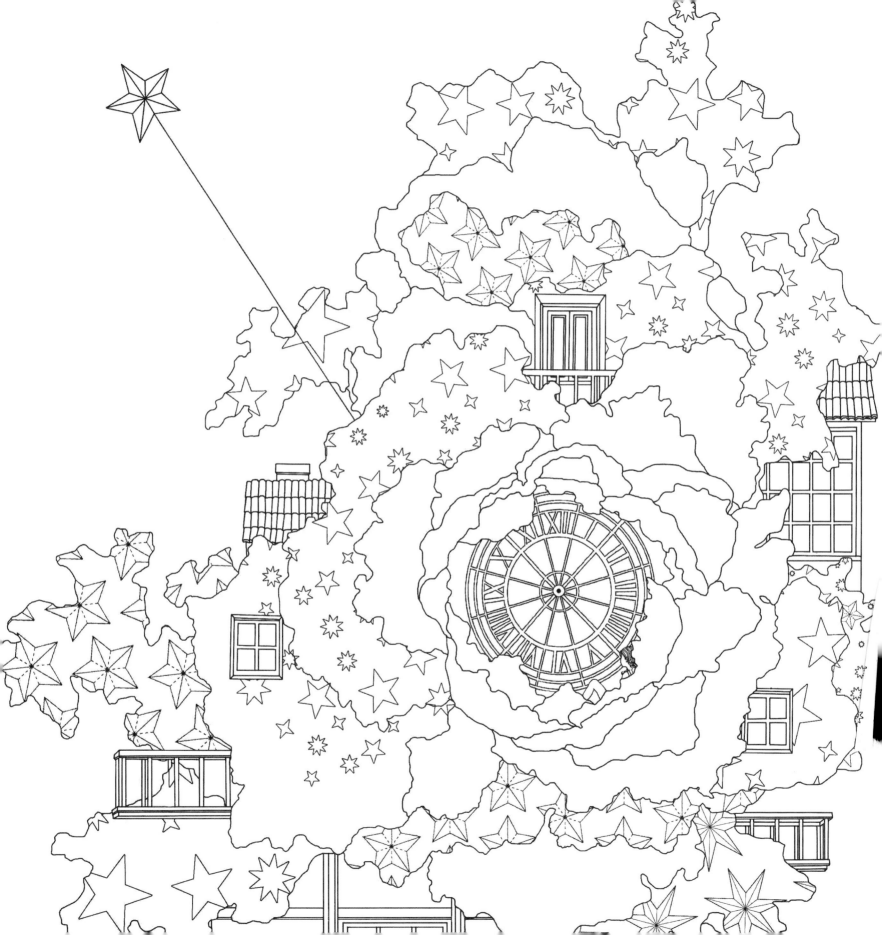

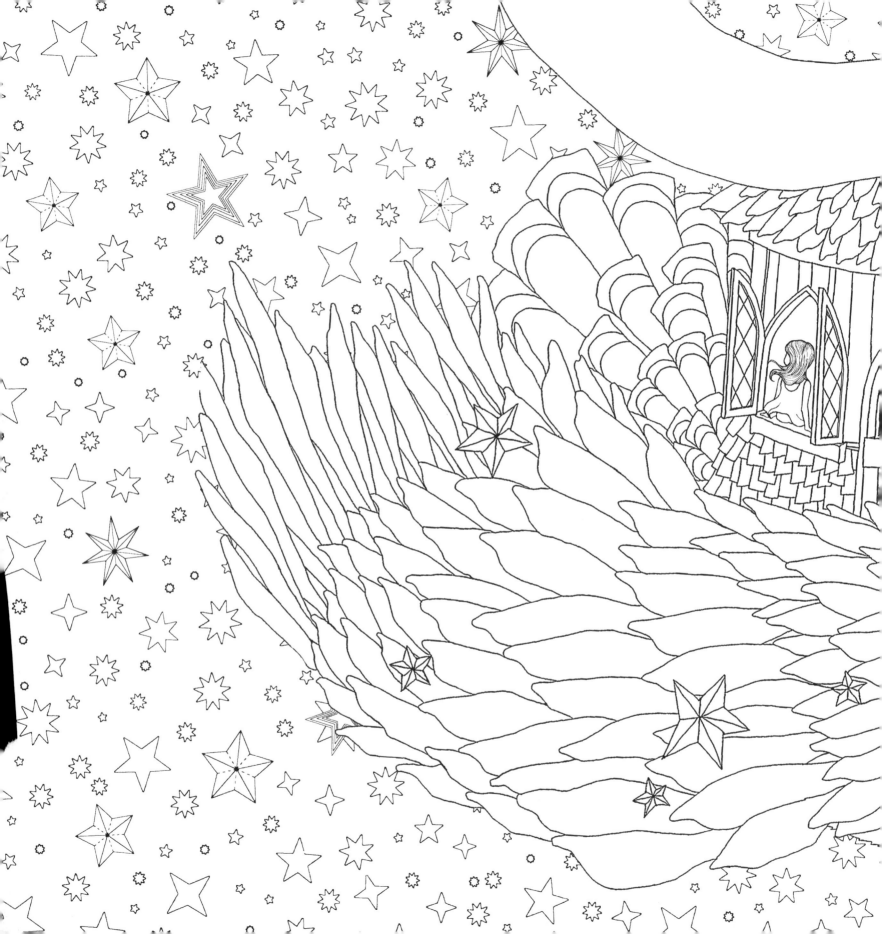

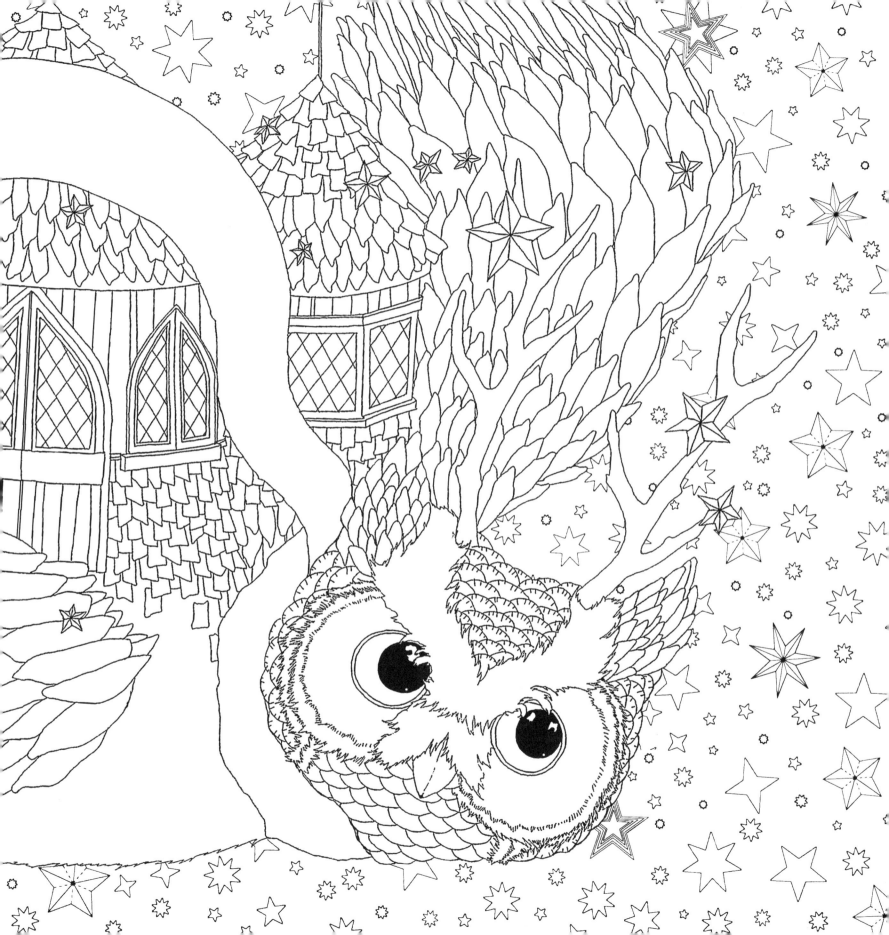

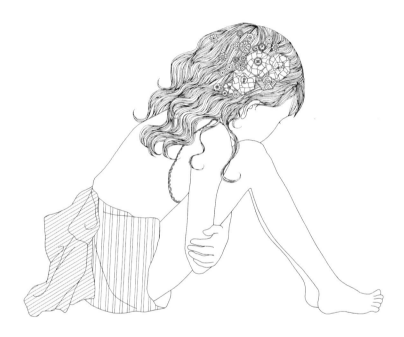

While leaning against the owl's fluffy feathers, the little girl
drifted off to sleep without realizing it.

How long had she been sleeping?

The bright sun woke her. It was morning, and
the little girl found herself back in the room
where it had all begun.

Where was the red-haired fairy?

What happened to the garden full of
flowers and clocks?

She wondered whether it had all just been a dream.

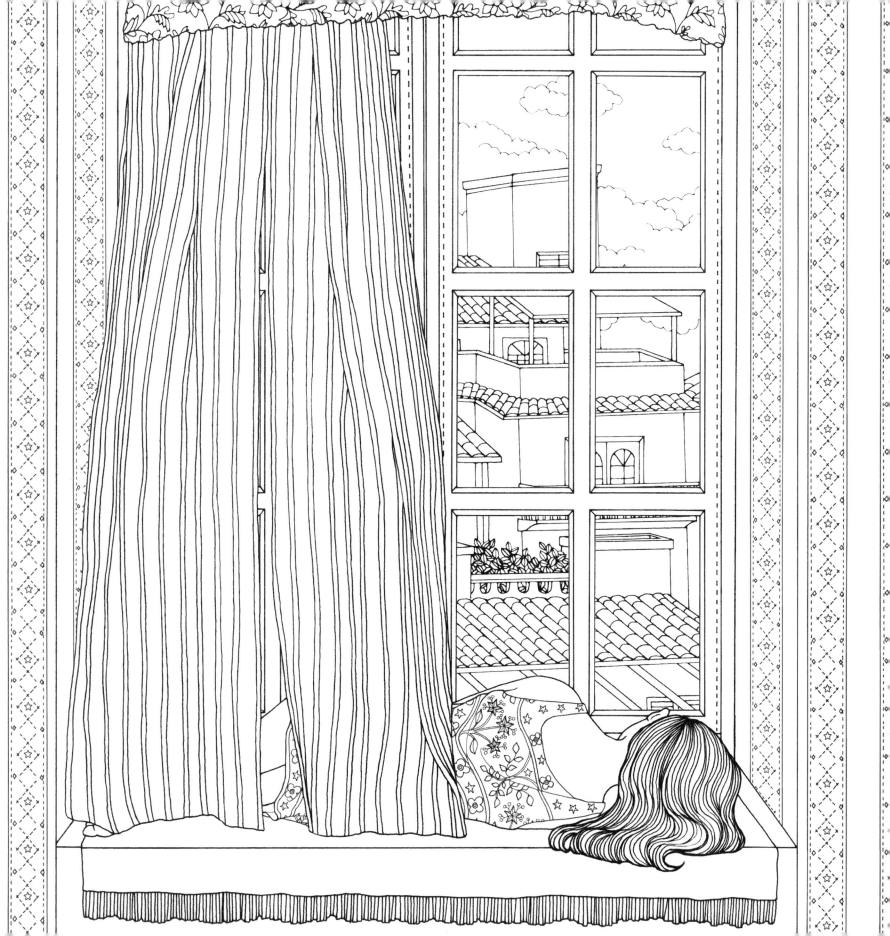

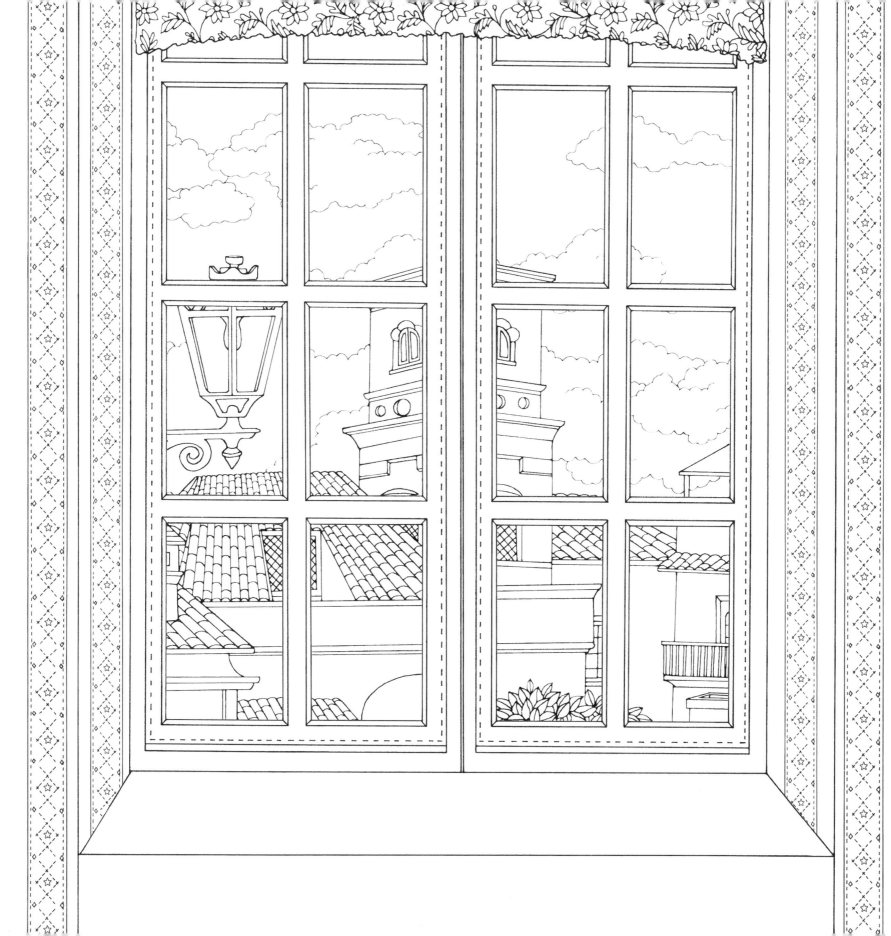

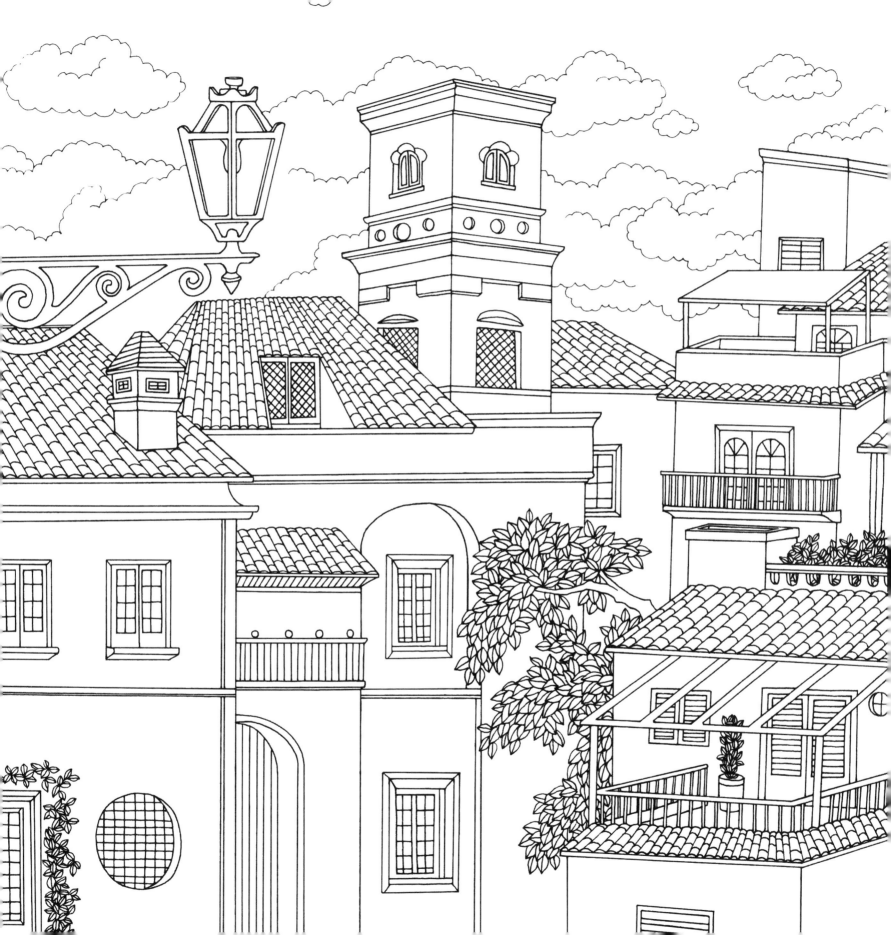

At that moment, the little girl heard the sound
of the cuckoo clock from the living room.

Cuckoo, cuckoo . . . cuckoo.

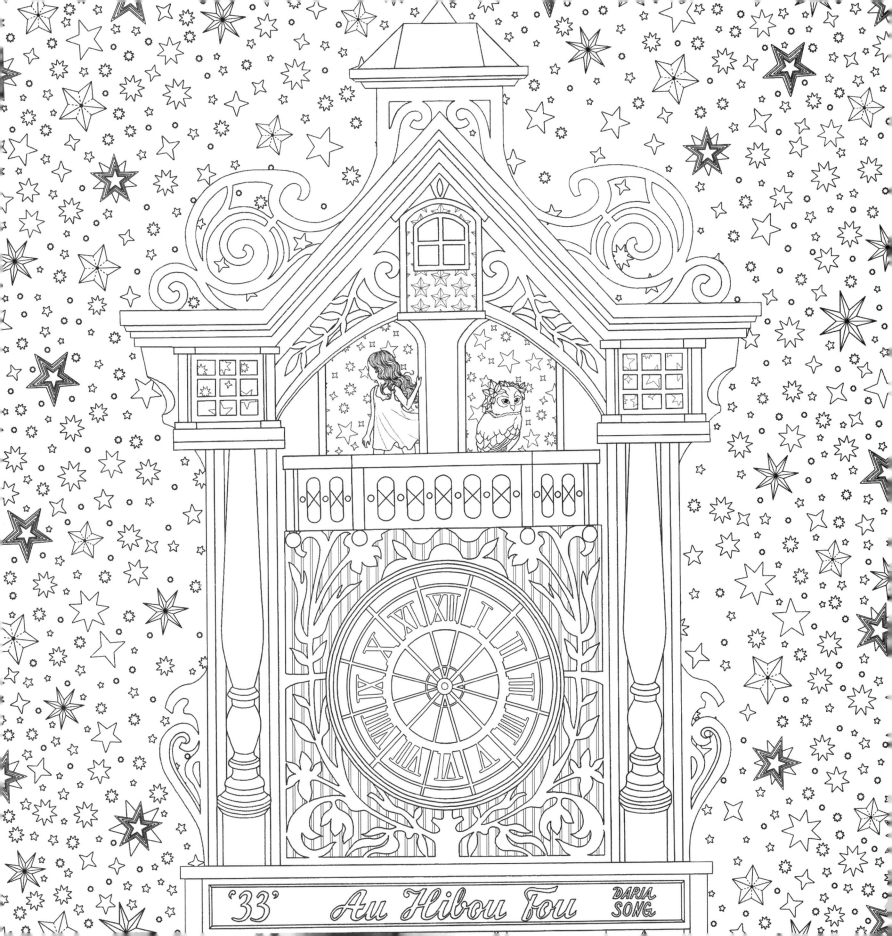

'33' *Au Hibou Fou* DARIA SONG

# Visual Index

Daddy's Cuckoo Clock

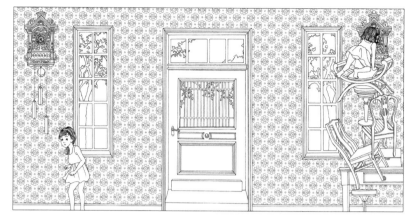

Girl and the Clock

Doorsteps

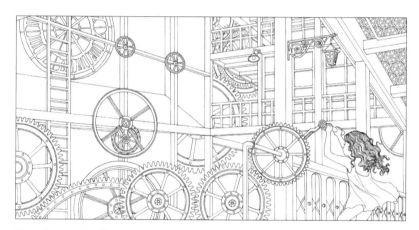

Fairy Inside the Clock

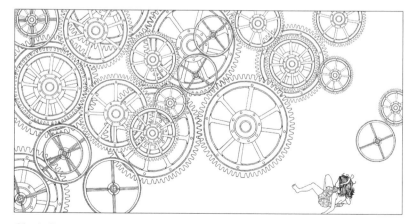

Clock Gears

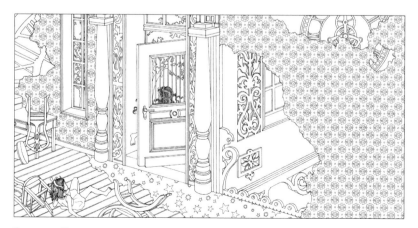

Runaway Fairy

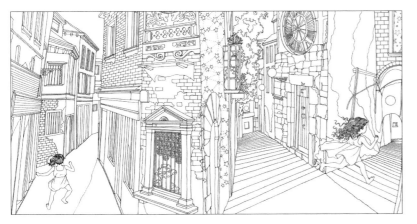

Chasing the Fairy

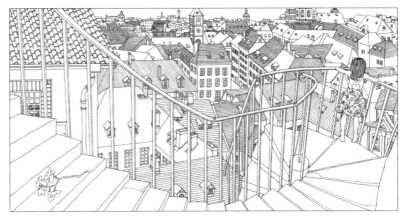

Rooftop Stairway

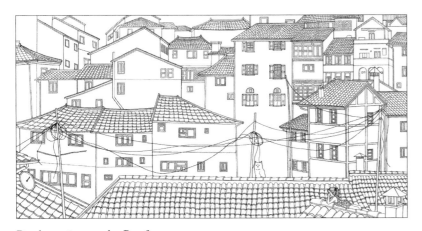

Daydreaming on the Rooftop

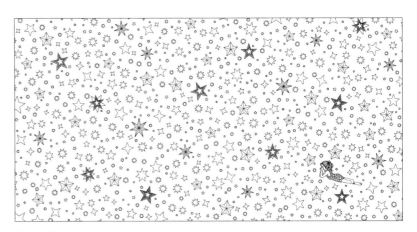

Catch the Stars

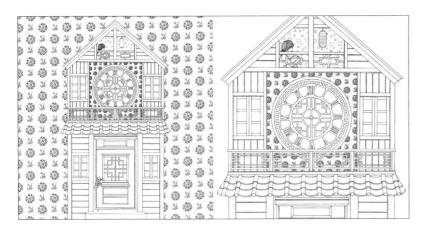

Starlight Starbright

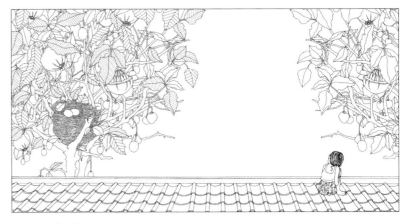

Tree on the Rooftop

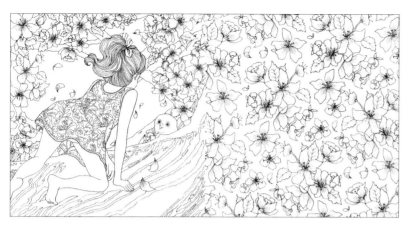

Midsummer Dream

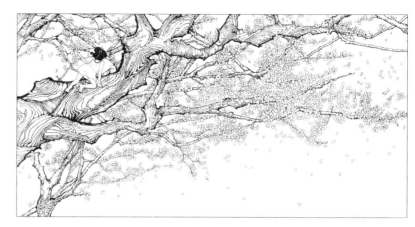

Midsummer Night Tree

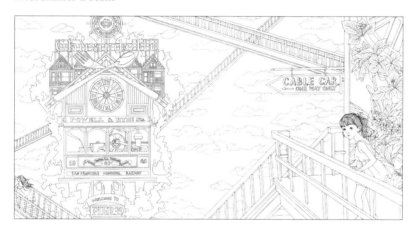

Ghirardelli Chocolate Factory

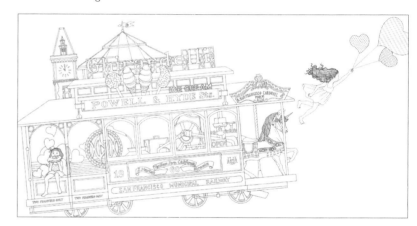

Ghirardelli Cable Car

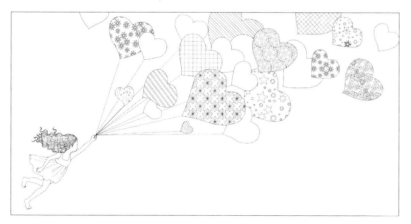

Heart Balloon Ride

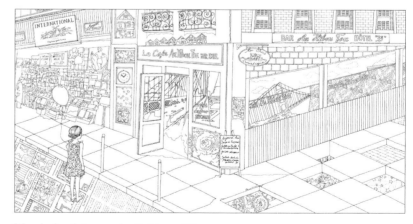

Wonderland Across the Bridge of Hope

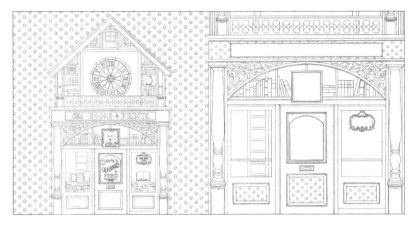

Shakespeare's Times

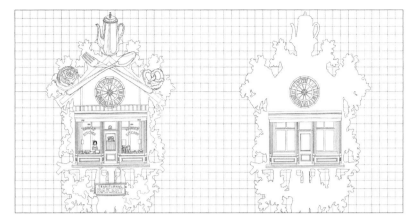

Mama's Kitchen

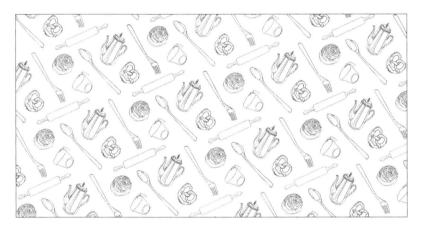

Kitchenware

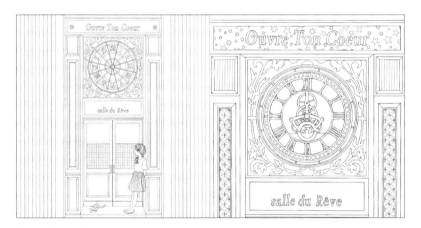

Open Your Heart

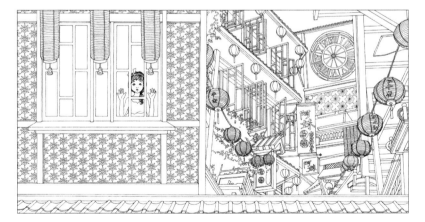

Jiufen

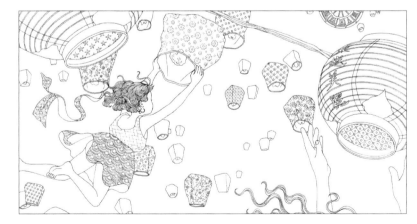

Flying Lanterns

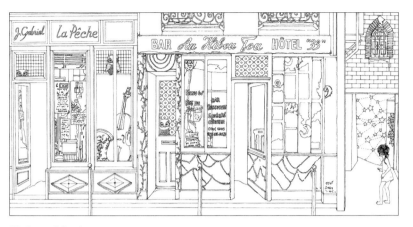

Hide and Seek

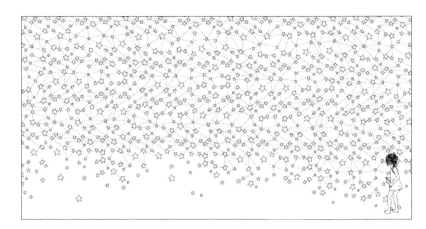

Underneath the Stars

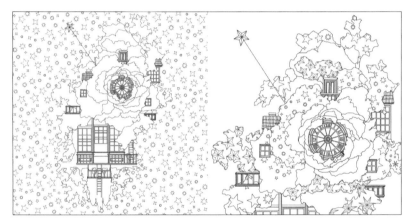

Bedtime Story

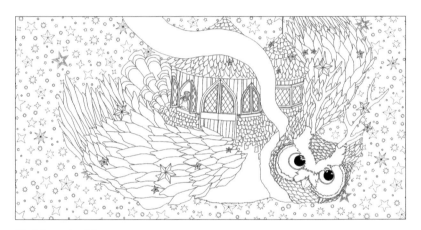

Fly Me to the Moon